foundation course

photography

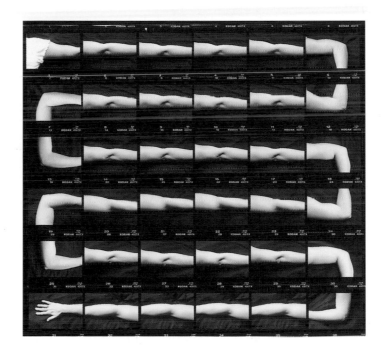

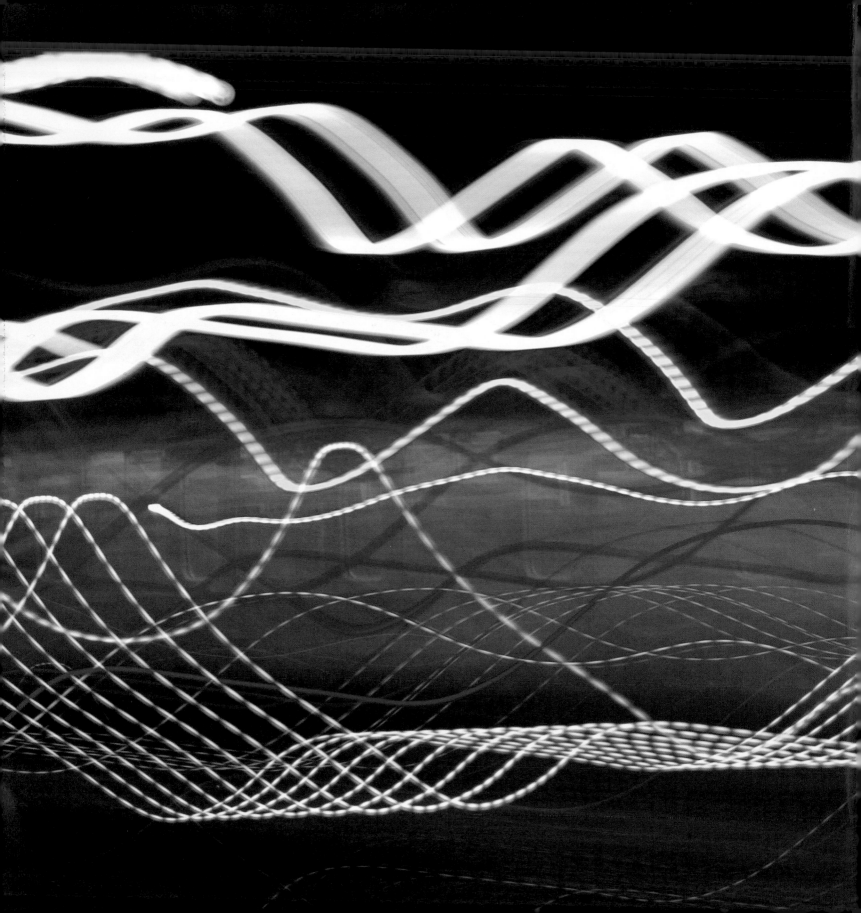

foundation course

photography

Peter Cattrell

CASSELL ILLUSTRATED

First published in Great Britain in 2005 by Cassell Illustrated
a division of Octopus Publishing Group Ltd.
2–4 Heron Quays, London E14 4JP

Text and design © 2005 Octopus Publishing Group Ltd.
Photographs © 2005 Peter Cattrell except those specified on
page 144.

The moral right to be identified as the author of this
Work has been asserted in accordance with the Copyright,
Designs and Patents Act of 1988.

Series development, editorial, design and layouts by
Essential Works Ltd.

Distributed in the United States of America by
Sterling Publishing Co., Inc.,
387 Park Avenue South, New York, NY 10016-8810

The author and publishers have made every reasonable effort to
contact all copyright holders. Any errors that may have
occurred are inadvertent and anyone who for any reason has
not been contacted is invited to write to the publishers so that
full acknowledgement may be made in subsequent editions of
this work.

A CIP catalogue record for this book is available from the
British Library.
ISBN 1 84403 221 3

EAN 9781844032211

Printed in China

Contents

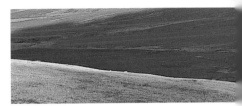

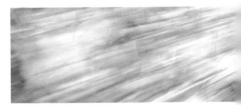

Introduction

The literal definition of the word photography is 'painting with light', and what could more perfectly describe the compelling mixture of creativity and science that is photography. Once drawn to the subject, and with a good grounding in technique, you can make your visual statement about the world. There is a magic that never fails to excite as you get your pictures back from the laboratory, see your print emerging in a developer tray, or look at the image on the screen of a digital camera.

Photography can become a lifetime's pursuit, a career, or just an enjoyable hobby. Many people kick off their interest in this subject by taking pictures of family and friends or holiday pictures, perhaps moving on to reading photography books and magazines before enrolling on a part-time course to learn more about technique. It's fun being part of group with a shared passion for a subject, learning from each other as well as the tutor. You can then go on to foundation level at art college, then a degree, before undertaking postgraduate study.

This book aims to guide you through the important areas of technique and visual ideas, much as a course would. You can dip in and out of sections, using them as a reference as and when necessary. The first chapter deals with the equipment and materials that are part and parcel of photography, explaining their different attributes and how they impact on the picture. The second chapter introduces a range of images and the photographic principles underlying them, intended to inspire you to look at the ordinary in a new way. Chapter three is a short course on processing and printing in black and white, while chapter four gives an insight into how photographers tackle a selection of specialist subjects. Finally, in 'Masterclasses' you will find step-by-step guidance on specific projects.

We are at an important time in the evolution of photography, as silver- and dye-based emulsions are being challenged by digital technology. The skills and understanding needed with digital are similar to those in traditional photography. The basics of photography and the crucial principles remain the same – camera handling, composition, lighting, and learning to visualize and select the potential from the scene before you.

Any experienced photographer should be able to come to terms with digital. The aim of this book is to help you understand the basic principles of photography, the core information that is relevant to both film-based and digital approaches. Look at the short bibliography at the end of the book if you need a volume dealing specifically with digital image manipulation.

History of photography

Before the invention of photography, artists used a device known as a *camera obscura*, literally a 'dark room', as an aid to rendering perspective correctly. Sitting inside a darkened room, the artist could trace the image of the outside world projected on to a piece of paper by a lens set in the front of the device. A major breakthrough in the search for some way of recording and preserving the action of light directly on paper came in 1727, when a German scientist, Johann Schulze, published a paper explaining how a mixture of silver nitrates could be darkened by being exposed to daylight.

Daguerre and Niépce

Schulze's discovery informed the work of other researchers, but the problem of how to preserve the image formed by the action of light remained unsolved until 1827, when French chemist Joseph Nicéphore Niépce produced the world's first permanent image using a *camera obscura* and white bitumen. The image required an eight-hour exposure in bright sunlight. French painter Louis Daguerre was familiar with the *camera obscura* and became obsessed with the idea of discovering a more practical method for making permanent the photographic image. Working in partnership with Niépce, Daguerre used mercury and iodine vapours to make stable a single image on a copper plate. Niépce died in 1833, and in 1839 Daguerre made public their process, winning the fame and acclaim.

Fox Talbot: an English gentleman

In England, physicist and artist William Henry Fox Talbot was searching for a way to make images permanent that had been projected on to specially treated paper. By 1835 his experiments with solutions of silver salts, which darken under light, were beginning to produce good results. Spurred by news of Daguerre's success in France, he broke the news of his own research and is

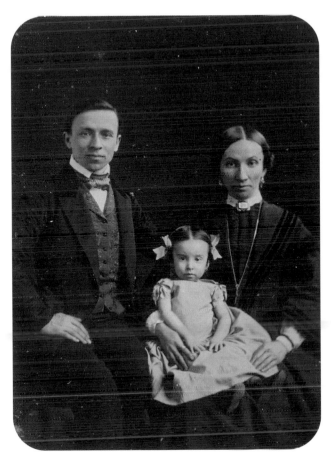

An English daguerreotype
This typically formal daguerreotype family portrait was taken in an English studio in 1885. The dark background makes the scene look austere, but detail is excellent and the image would have been a treasured object.

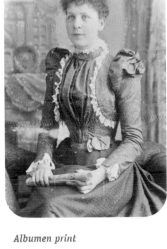

Albumen print
Perhaps this photograph was taken to record a special occasion, as the young woman is well dressed and arranged in front of a painted backdrop. This is an albumen print from a collodion glass plate negative – the technique that took over from the daguerreotype. Any number of prints could be made from the original negative, adding to the photographer's profits, but also making the image more accessible to friends and family.

regarded as the inventor of the negative/positive process. This differed from Daguerre's approach as any number of positive prints could be made from a single negative. Fox Talbot called his process the calotype, from the Greek *kalos*, meaning 'beautiful', and patented it in 1841.

With improved emulsions and shorter exposure times, portraits became a practical proposition and there was a boom in photographic studios as people queued to have their likeness taken. The daguerreotype was very popular, especially in

America – though after a 30-second exposure, sitters tended to look a little strained.

In 1844 Fox Talbot published *Pencil of Nature*, the first photographic book, with 24 original calotypes. He never made a profit from his ventures, but people were drawn to the beauty of the calotype, and in patent-free Scotland it really took off. The painter David Octavious Hill and the chemist John Adamson produced portraits in Edinburgh, including a series on churchmen, and documentary pictures of a fishing community.

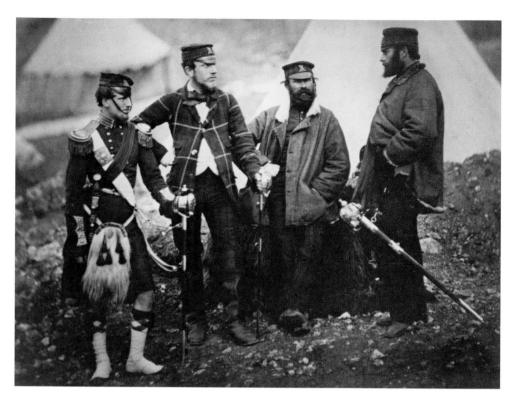

A grave reality: war and social reform

Englishman Roger Fenton travelled to the Crimea in 1855 to document the war with Russia, and returned with portraits of soldiers and battlefields, but none of the atrocities he had seen. American Mathew Brady and his team covered the American Civil War in the 1860s, showing the carnage and destruction, as well as formal portraits.

In 1868 a Scot, Thomas Annan, photographed the Glasgow slums as an impetus for social reform, and Englishman John Thomson did similar work in London. In the United States Jacob Riis photographed social problems in the tenement slums of New York using the new invention of flash. And Lewis Hine recorded how children were being exploited in factories, which led to the introduction of a minimum working age in the US.

Platinum, gum, and colour

The steady improvement in photographic processes continued when images on platinum paper proved to be more permanent than those

A sanitized view of war

A group portrait of officers of the 42nd Highland Regiment, one of Roger Fenton's 350 images of the Crimean War taken in the spring of 1855. He had a portable darkroom that became so hot he had to work early in the morning, before the sun became too strong.

Glass plate negatives

English sculptor and photographer Frederick Scott Archer began making negatives on glass in 1848, using a wet collodion silver-based emulsion, which gave much finer detail than had been achieved before. This was the most used negative/positive process until 1878, when dry plates with a silver-gelatine emulsion became available. Albumen prints, made from egg whites, produced from travel plates of India, China, and Egypt, proved very popular, bringing detail of famous and remote places into people's homes.

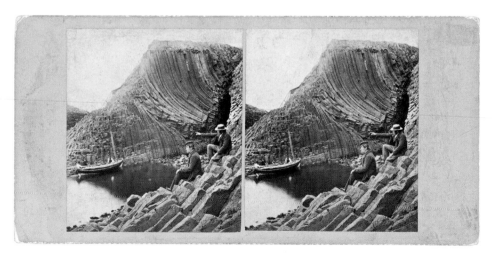

Stereo pairs

A stereoscopic pair, by Scots photographer George Washington Wilson, of Fingals Cave on the Isle of Staffa, produced in about 1880. When seen through a special viewer these two images, taken from slightly different viewpoints, are merged by the brain and appear as a single, three-dimensional scene.

on silver-based paper. In addition, they also had a fuller tonal range. Platinotype paper was made commercially from 1878, and the gum bichromate process, which didn't use metal salts, was becoming popular as the resulting prints looked a little like paintings.

In 1861 Scots scientist James Clerk Maxwell made the first colour photograph, of a piece of tartan, by projecting the image through jars of coloured dyes. French brothers Auguste and Louis Lumière patented the autochrome in 1904, which was a glass colour transparency utilizing starch grains. Dufay colour followed, and then Agfa colour from Germany, which led the market until Kodachrome was invented in the 1930s.

American artist-photographers

Alfred Stieglitz, born in New Jersey in 1864, studied photography in Berlin before returning to New York where, in 1902, he was co-founder of the Photo-Secession Group, devoted to photography as a means of artistic expression. In his gallery he showed the French Cubists, and his own images of nudes and of skies took photography a step into the modern era. His theory of 'equivalence' suggests that tonalities in a print can be an equivalent of different emotional moods.

Other American photographers of great importance in the early twentieth century include Ansel Adams, best known for his monumental approach to the American landscape; Edward Weston, known for his nudes and sensuous still-lifes; and Minor White, famous for his introspective and expressive abstractions.

In the 1930s photographers for the Farm Security Administration (FSA) were commissioned to show the rural poverty of the Depression years. This became a landmark project and helped the careers of photographers such as Walker Evans, Dorothea Lange, and Ben Shahn. Robert Frank documented urban America in the 1950s with a raw style of gritty realism.

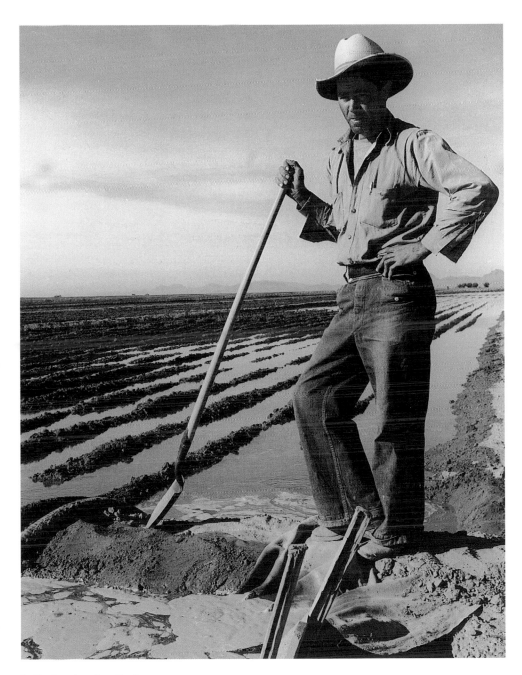

In the American heartland
Working for the FSA, Dorothea Lange photographed the migrant workers, sharecroppers, and tenant farmers of mainly the South and West of America. This image, of a Mexican migrant farmworker, was taken in Arizona in 1940.

The middle and later years of the twentieth century are punctuated with photographers of note and influence, including Edward Steichen, Irving Penn, and Richard Avedon. These photographers combined successful careers in commercial photography with interesting personal projects, such as Penn's *Worlds in a Small Room*, and Avedon's *In the American West*.

Arnold Newman and Annie Leibovitz are both major figures in portrait photography, though with different styles, and Cindy Sherman has produced a series of self-portraits that challenge the way women are represented in art and the media.

European social documentary

The upheavals of the twentieth century gave rise to a photographic tradition in Europe dealing with the social issues of the times. In the 1920s, German photographer August Sander documented every profession and social group, including the unemployed, for his project *The Face of Our Time*. He used a large-format camera to take posed, set-up pictures. However, the invention of the Leica 35mm rangefinder camera in the 1920s freed later photographers to take more spontaneous, candid imagery, heralding the reportage style of those such as Henri Cartier-Bresson and Robert Doisneau in France.

A giant of the twentieth century was London-based photojournalist Bill Brandt, whose portrait, landscape, and reportage imagery depicted the divide between the industrial north and the middle classes in London. His career started in Paris in 1929, and his later nude studies, and much of his other portrait work, show how he was influenced by the Surrealists. There is also a surreal edge to the work of Czech photographer Josef Sudek, evident in his still-lifes and panoramic views of Prague through to the 1970s.

In the 1960s two Londoners came to prominence – David Bailey, a fashion and portrait photographer, and Don McCullin, a war photographer covering the Vietnam War.

Since the 1970s, a strong theme has been the urban and rural landscape. In Germany, Bernd and Hilla Becher have produced large-format images on such industrial subjects as water towers and coal mining. Their influence on students at Düsseldorf Academy, who are now at the forefront of art photography, has been huge.

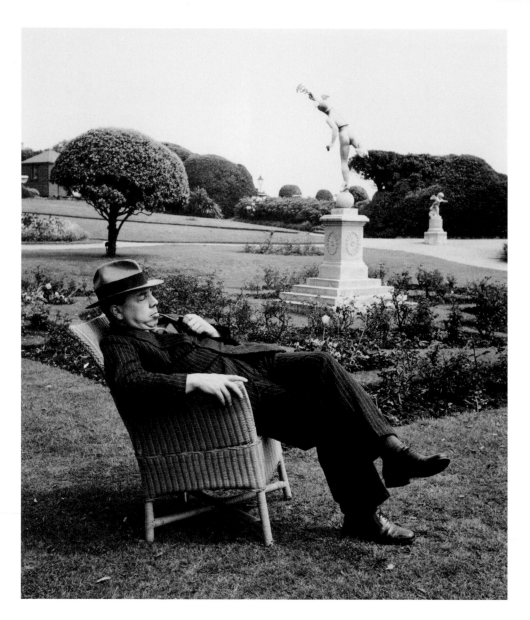

Artist at rest

This photograph of English writer JB Priestley shows the humour that characterizes so much of Bill Brandt's portrait work. Taken in 1941 with the Battle of Britain not yet won, the picture was for a story in Picture Post *magazine on the seaside town of Bournemouth as a place for war workers to relax.*

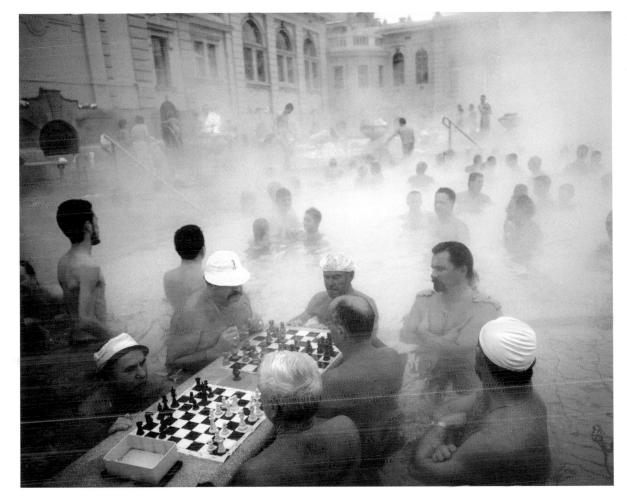

In Britain, Fay Godwin has had a wide-ranging career, taking portraits, landscapes, and, more recently, colour abstracts. Her landscapes have received worldwide acclaim. Paul Hill was initially a photojournalist, but became more involved in teaching. His personal projects include exquisite landscape work, especially of the Peak District of Derbyshire. Martin Parr has received much critical acclaim as a reportage photographer, and has recently been experimenting with ring flash outdoors, producing strikingly bright colour images. His work has centred on the shopping malls of Britain and the tourist industry abroad.

New directions

Equipment today is so sophisticated, it is difficult to conceive of the difficulties the pioneering photographers faced. Today, access to a camera is so common that almost everyone in the Western world has used one or had their picture taken.

The history of photography is as much about changes in society, attitudes, and art as it is about technology and the development of better cameras and films. Studying for a degree at art college includes cultural theory, and putting the practice of photography into a cultural context.

Photographs reflect ideologies and lend themselves to analysis because, in many ways, the context in which you see a picture determines its meaning.

Digital cameras will become cheaper, and improvements in software, printers, and inks will make it easier to get the very best quality. At present there is still demand for the traditional methods of photography, and students love rediscovering the old nineteenth-century processes. And galleries are showing larger and larger prints as photographers commission industrial-scale laboratories to print their work.

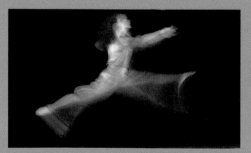 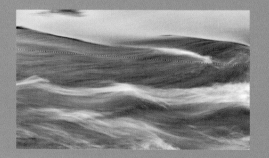

Equipment, materials, and techniques

What is a camera?

Essentially, a camera is a closed box with a strip of light-sensitive film on one side of the interior and a hole opposite to admit light from a subject. With the exception of the most basic pinhole cameras, all cameras have a lens, which allows you to focus on a specific part of a scene and to take pictures of subjects at different distances from the camera. There is also a light meter in the camera to tell you how much light is reflecting back from the subject so that the film receives just the right amount of exposure. And finally there is an integral viewfinder that allows you to see the subject from the camera's point of view.

Film cameras

Direct-vision viewfinder

The direct-vision viewfinder design is neat and compact. It has a separate viewfinder window towards the top of the camera body, just to one side of the lens, that gives you a direct view of the subject. These cameras are primarily aimed at amateur photographers and most modern types feature autofocus lenses. Although these are not particularly flexible cameras, they are capable of good results under a range of standard lighting conditions.

On some good-quality cameras there is a second, 'rangefinder', window linked to the focusing mechanism. This system allows you to see when the subject is in focus when looking through the rear eyepiece. The most famous of these cameras is the Leica rangefinder, which also accepts a range of interchangeable lenses.

Light paths through the camera

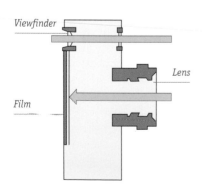

In a simple direct-vision viewfinder camera you view the subject through a window above the lens.

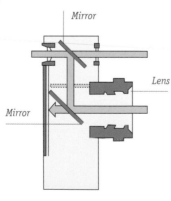

In a rangefinder camera two views of the subject are combined and appear sharp in the viewfinder when the lens is in focus.

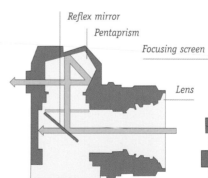

In an SLR camera light from the lens is directed up into the viewfinder, so you always see exactly what the picture will be.

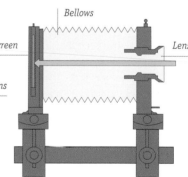

In a view camera light enters the lens and, when a darkslide is removed, exposes an individual piece of sheet film.

Pinhole imagery
The camera that produced this picture (see also pp. 124–7)
did not even have a lens – instead, a tiny pinhole-sized
aperture focused light from the subject onto a piece of
printing paper. The shutter, a wooden panel on the front
of the camera, is swung aside manually to allow light to
enter. As the aperture is so tiny, about only f256 (see
pp. 16–19), the normal shutter speeds of fractions of a
second are more likely to be several seconds long with
this instrument. At the end of the manually timed
exposure, you must swing the shutter closed once more.
As you can see here, the image from a pinhole camera
does not have the definition and clarity you would expect
from a modern camera lens.

SLR

With the single lens reflex, or SLR, camera light from the subject travels through the lens, into the camera body, where it is reflected upwards by a reflex mirror into a pentaprism, the interior surfaces of which are also mirrored. From here, the light is reflected out through the rear eyepiece. This complex arrangement allows you to see an image correctly orientated in all respects (correcting the upside-down image produced by the lens and the laterally reversed image reflected by the reflex mirror). The SLR design, both 35mm and medium-format types (see pp. 24–7), is a very accurate way of viewing the subject, as when you look through the eyepiece you see the actual image produced by the lens. And every time you change lenses, or settings on a zoom lens, the image in the viewfinder remains accurate.

Large format

Large-format cameras are not commonly seen outside of the professional studio. With these, a flexible bellows connects the lens panel to a ground-glass focusing screen at the rear. To increase contrast and so make the image on the screen easier to see, it is common to use a black cloth to shade the screen and cover your head. A single sheet of large film is then slid into position and exposed.

Any camera lens will project an upside-down image, but this type of camera does not offer any correcting aids. It is a painstaking way of working and suitable only when accurate photographic enlargements of the finest quality are required.

Digital cameras

Entry-level digital cameras are largely automated, easy to use, and have direct-vision viewfinders. But, like their film-camera equivalents, SLR digitals generally offer better results under a more varied range of lighting conditions.

The optical side of digital cameras is very similar to that of film cameras, but rather than the light being directed to a strip of film, it falls on a light-sensitive electronic sensor known as a CCD (charge-coupled device). The CCD is made up of a grid of minute cells, each sensitive not only to the intensity of the light falling on it, but also to its colour. Each cell of the CCD transmits the light and colour characteristics of its part of the picture to a central processing unit (CPU), where an electronic file of the whole image is created and recorded on a memory card.

Memory cards have a finite capacity and the higher the resolution of the recorded image, the fewer images can be accommodated. Because of this, digital cameras give you the option of saving pictures, or image files, in a compressed fashion. The higher the rate of compression, the more images the memory card will hold, but the poorer will be their quality. Set the quality of the file for its intended use. For example, a highly compressed file might be suitable for a website, while an uncompressed image might be required for big enlargements. Memory cards can be downloaded into your computer or a more portable hard-drive device, the files deleted, and the card loaded back into the camera for reuse.

Digital image quality is dependent on the number of pixels (the basic digital picture element) per image the CCD can record – the more, the better. Entry-level cameras may have only 1- or 2-megapixel (millions of pixels) capacity, but 6-megapixel cameras are now commonly available, and even SLR models are becoming more affordable all the time.

Apertures and depth of field

The lens aperture is the size of the opening in the lens through which light reaches the film. A series of overlapping blades can be adjusted via a ring on the lens or, more commonly today, a button on top of the camera, to alter the size of the opening in a series of 'f-numbers'. The choice of aperture, along with shutter speed (see pp. 20–3), is crucial not only to correct exposure, but also to the degree of image sharpness. While you are composing the picture through the viewfinder the aperture stays wide open, giving you the brightest possible image to look at, but it automatically closes down to the preselected f-number when you fire the shutter.

Apart from the effect changing apertures has on exposure, whenever you make the aperture smaller or larger you alter the zone of sharpness within the image. This zone of acceptably sharp focus, known as 'depth of field', extends both in front of and behind the point actually focused on.

Factors affecting depth of field

Depth of field is not fixed. In fact, there are three main factors that determine its extent. First is lens aperture (see below): the smaller the aperture (denoted by larger aperture numbers), the greater the depth of field. Therefore, f2 (a wide aperture) will have an inherently shallower depth of field than, say, f16 (a small aperture).

The second factor affecting depth of field is lens focal length: wide-angle lenses produce an inherently greater depth of field than normal or telephoto lenses. Therefore, a 135mm telephoto lens will give pictures with a shallower depth of field than a 28mm wide-angle.

The final factor affecting depth of field is the focus distance of the subject. The further away you focus the lens from the camera the greater the resulting depth of field. Therefore, a lens focused at 1m (3ft) from the camera will produce a shallower depth of field than that same lens, set at the same aperture, focused at just 3m (10ft) from the camera.

Controlling exposure

The sequence of apertures shown below is that typically found on camera lenses. You can see that the larger an aperture's f-number, the smaller the actual opening. Each time you alter the aperture by one full setting, or 'stop', you either halve or double the area of the opening, and so halve or double the amount of light transmitted by the lens. In other words, changing the aperture from f4 to f5.6 halves the amount of light reaching the film; changing it from f4 to f2.8 doubles the amount of light getting through.

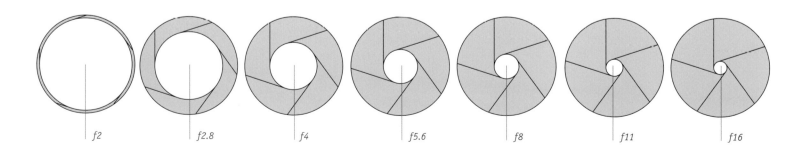

| f2 | f2.8 | f4 | f5.6 | f8 | f11 | f16 |

Altering the lens aperture has two effects on the photograph. First, as described opposite, it changes the amount of light reaching the film and so is a factor in exposure. Second, each time you stop down (make the aperture smaller) you increase the depth of field within the image. In these diagrams you can see that changing the aperture from f1.4, through f5.6, to f16 has an enormous affect on the amount of the image that would be sharply rendered (represented by the darker shade of blue). The lens remains the same each time, as does the focusing distance (represented by the figure) of the lens.

Changing aperture

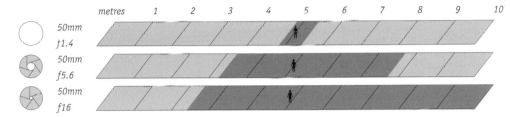

Changing the focusing distance of the lens, while keeping the aperture the same (at f5.6), also affects depth of field, though to a lesser extent. These diagrams show that the closer the subject being focused on is to the lens, the shallower will be the depth of field.

Changing focusing distance

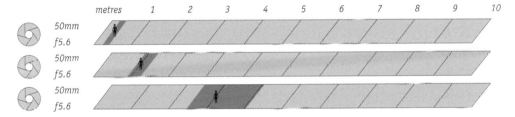

The third major factor affecting depth of field is the focal length of the lens. In these diagrams, the aperture is set at f5.6 each time and the focusing distance is constant. But as you can see, the 28mm wide-angle lens has an enormous depth of field, while that of the 210mm telephoto is very shallow. Accurate focusing becomes more of an issue as depth of field decreases.

Changing focal length

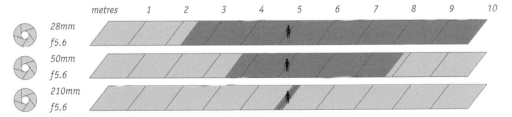

TIP

Portrait and reportage photographers often use middle-range apertures, such as f8 or f11, for optimum image quality. Some image distortion is possible with either extremely small or extremely large apertures, though except on very poor lenses any distortion should be only slight.

Selective sharpness

This set-up amply illustrates the creative potential of depth of field. In the first image of the pair (near right) the 55mm lens was set at f5.6 and focused on the central black jug, but the zone of sharp focus at this aperture does not extend even a few centimetres, so the foreground mug and background jug are rendered softly out of focus. This is ideal if you need a technique to isolate a subject from, say, cluttered surroundings. In the next shot (far right) the aperture was stopped down to f22 and now depth of field amply covers all three objects, though the shutter speed had to be changed to compensate for the reduced amount of light passing through the lens (see pp. 20–3).

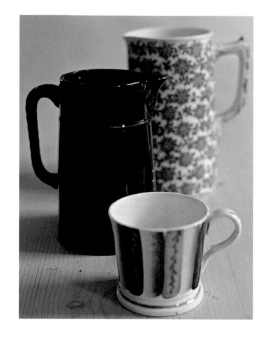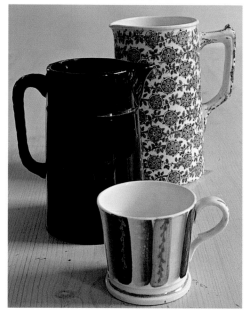

Selective emphasis

Once you have come to terms with the pictorial effects that changing apertures has on the image, you can apply the technique in all manner of situations. In this photograph, showing a pierced stone screen in an Indian temple, a telephoto lens with the aperture wide open at f4 and focused as close as the lens would permit has produced a shallow band of sharp focus and so emphasized this one small part of the image area. The coloured threads, each representing a prayer from a devotee, add to the abstract nature of the shot.

Creative factors

Given the right combination of circumstances – say, a 135mm lens set at an aperture of f4 and focused at 1.2m (4ft) – depth of field could be so shallow as to make it impossible to render sharply all of a person's face, unless it's in profile. Move in closer still, to the close-focusing distances of the macro world, and it might be impossible to show all of even the smallest garden flower in sharp focus.

Traditionally, landscape, still-life, and architectural photographers have manipulated depth of field by using apertures of f22 or smaller to give sharp images from the immediate foreground right through to the far distance, or infinity (the ∞ symbol on the lens focusing ring). A more modern trend, however, is to limit depth of field in order to isolate specific subject elements or to force the viewer's attention on to a specific area of the image.

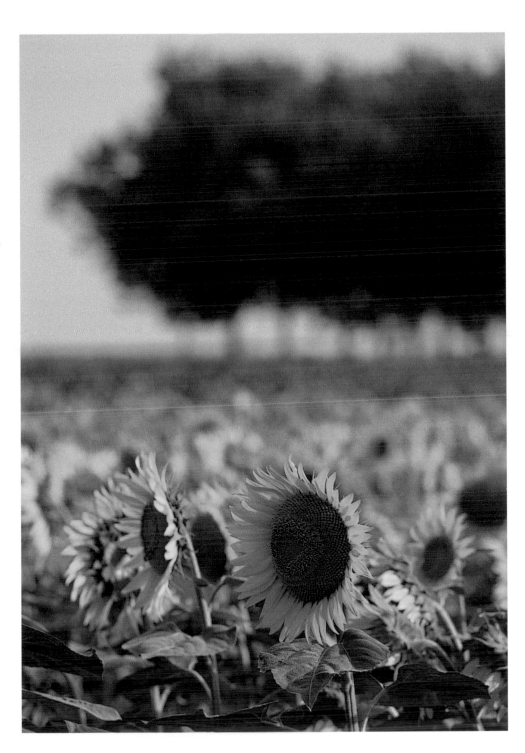

Deceptive distances

Although depth of field here appears to be extremely shallow, what you cannot see from the angle the picture was taken is that the front rank of sunflowers was separated from the rest of the field by a wide ditch.

Shutter speeds

As light passes through the lens aperture (see pp. 16–19), a shutter opens to allow it to reach the film or, with a digital camera, a CCD sensor (see p. 15). So, by controlling the length of time the shutter remains open, you have the second half of the exposure equation: intensity x time. The intensity of the light from the subject is determined by the size of the lens aperture, while the length of time that intensity of light is allowed to act on the film or sensor is determined by the shutter speed.

As a guide to helping you choose the 'correct' exposure – in other words, the right combination of aperture and shutter speed – all modern cameras have a built-in light meter. To do its job accurately, the light meter not only has to read the overall light reflecting back from the main subject and its surroundings, it also has to take into account the speed of the film loaded in the camera (see pp. 34–5), or the sensitivity setting of the CCD sensor.

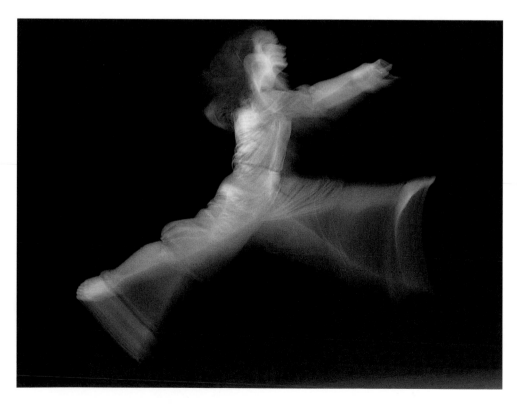

TIP

To avoid camera shake with a 35mm camera, set the shutter speed closest to the focal length of the lens. With a 50mm lens use $\frac{1}{60}$ sec; with a 135mm lens use $\frac{1}{125}$ sec; with a 200mm lens use $\frac{1}{250}$ sec; and so on. For speeds slower than $\frac{1}{60}$ sec, use a tripod or some other support to guarantee sharp images.

Creative blur
With a shutter speed of $\frac{1}{8}$ sec it was possible to capture the excitement and energy of this dancer by recording all movement as blur. To prevent camera shake spoiling the effect, the camera was tripod mounted.

Recording movement

Not only does shutter speed help to determine exposure, it also affects the way the subject is recorded. For example, if you select a shutter speed of ⅟₁₂₅ sec then you are likely to 'freeze' such subjects as people walking or jogging, or cars travelling at moderate speeds. That same shutter setting, though, is unlikely to freeze the movement of a speeding train or sprint runner. But don't fall into the trap of thinking that subjects always need to be recorded with clinical sharpness – by deliberately selecting a slow shutter speed you can record subject blur and so produce what may be a more evocative and appealing image.

Another way to record subject movement is to 'pan' the camera. Using this technique, you move the camera to keep the subject in the same area of the frame while the shutter is open and the image is being recorded. Thus, the subject remains relatively sharp while all the background and stationary parts of the scene become elongated into streaks and blurs. For the most dramatic results, choose a slow shutter speed – say, ⅟₁₅ sec – as the faster the shutter speed, the less the background will blur.

Deliberately creating subject blur as a means of interpreting subject movement is very different from the type of blur caused by camera shake.

Sharp and blur

Although a shutter speed of ⅟₁₅ sec was not enough to halt the movement of this speeding train (above right), by supporting the camera on a convenient wall it was possible to ensure that all other parts of the scene were recorded pin sharp.

A new perception

A shutter speed of ¼ sec was used to photograph this rapidly flowing stream (right), giving us the opportunity to perceive water in an entirely new way.

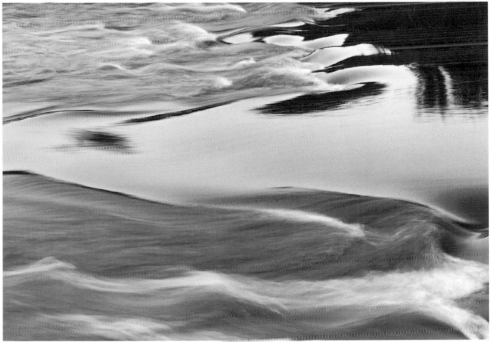

Most of the pictures we take we want to be clear and sharp, so try to keep the camera perfectly still as you gently squeeze the shutter release button. Jabbing down sharply on the shutter release will cause the camera to dip just as the image is recorded and results will nearly always look like a mistake.

Shutter types

Different camera formats can have different designs of shutter. For example, 35mm cameras have what is known as a focal plane shutter inside the camera body, situated just in front of where the light from the lens comes into focus. Most medium-format cameras have a 'leaf' or 'bladed' shutter built into the lens (the exception being the Pentax 6 x 7cm, which has a focal plane shutter). Large-format cameras also have a bladed shutter in the lens; while the basic pinhole camera has a shutter in front of the lens in the form of a wooden lens cap that you swivel across by hand after a manually timed period.

The focal plane shutter consists of slatted metal blinds on spring-loaded rollers. The significance of this is that at shutter speeds faster than, on most 35mm cameras, about $1/250$ sec, the blinds are not all open at the same time and the image is recorded as a slit moving in front of the film or sensor. Knowing this becomes important when using accessory electronic flash or studio flash (see pp. 36–7), which can produce an intense burst of light as short as a mere $1/10,000$ sec in duration. Unless this light fires when all the blades are open, part of the image will not be recorded. To avoid this problem occurring, most manufacturers of 35mm cameras have a flash-

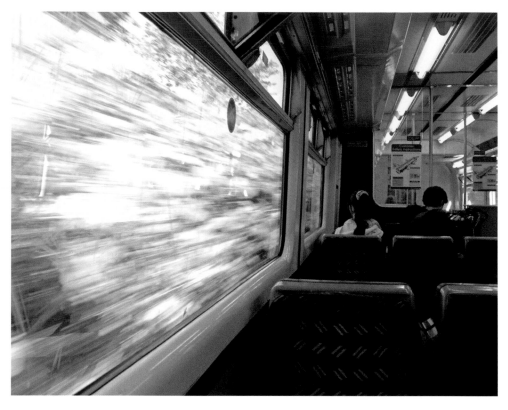

Contrasting moods
The contrast between the calm interior of this train carriage and the trackside foliage outside hurtling by outside is immediately striking. Fill-in flash was used to light the interior, so countering the green colour cast that would have resulted from the fluorescent tubes, and a shutter speed of $1/30$ sec creates the effect of blur outside.

synchronization shutter speed of $1/250$ sec or slower. The flash-synchronization setting on camera controls is often denoted by a lightning bolt symbol or an X.

The leaf shutter found in medium-format camera lenses opens and closes somewhat like a lens aperture, and no matter what shutter speed is set the shutter is either fully open or fully closed. This means that electronic flash will synchronize with any shutter speed. The disadvantage here is the extra cost of including a built-in shutter in each lens.

Exposure alternatives
If your light meter indicates that an aperture of f5.6 and a shutter speed of $1/60$ sec is the correct exposure, then all the other combinations of settings on this chart will give the same overall exposure. What does change is the depth of field and the way any movement is recorded.

Aperture numbers	f1.4	f2	f2.8	f4	**f5.6**	f8	f11	f16	f22	f32
Shutter speeds (sec)	1/1000	1/500	1/250	1/125	**1/60**	1/30	1/15	1/8	1/4	1/2

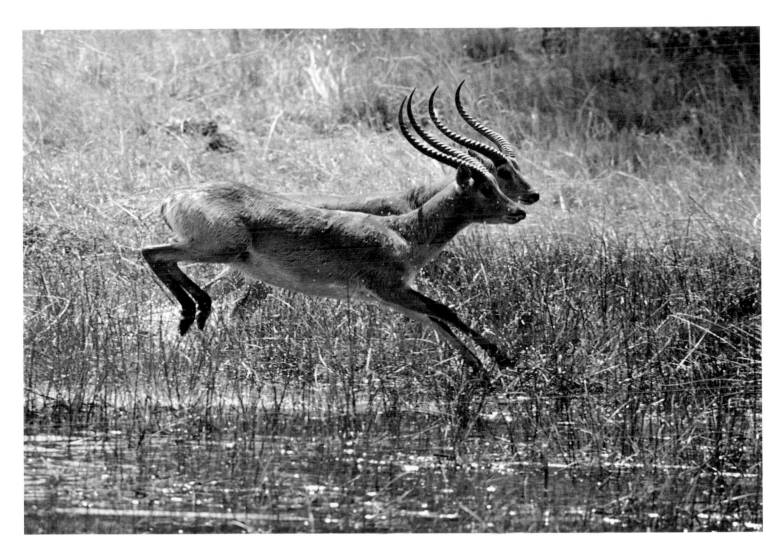

Shutter lag

A potential drawback with many cameras, but especially some digital models, is known as shutter lag. This is the delay between the time when the shutter release is pressed and the image is actually recorded. This problem is caused by the processing time the camera needs to record each image. It is most obviously a concern with the more basic and inexpensive digital models, where shutter lag can be very noticeable. This rules these cameras out whenever the timing of the shot is crucial – as it would be for any type of action or sports photography, for example. With good-quality digital compacts and SLRs, however, shutter lag should not represent a problem.

Frozen movement

There is no right or wrong way to record movement. To freeze the movement of these two leaping red lechwe, southern African antelope, the photographer used a shutter speed of 1/1000 sec on a 400mm lens. Here you can see them in almost clinical detail. An equally valid, though totally different, approach to the subject might have been to set a shutter speed of only 1/30 sec and then panned the lens as they passed the observation point.

Camera and film formats

The term 'format' refers to the shape and size of the film used in a camera and to the camera itself. The most popular format by far is 35mm, and these cameras are generally easy to handle, versatile, and capable of excellent results. When even better images are required, larger films are made for what are known as medium-format and large-format cameras.

In past times the classic Box Brownie was the favourite camera not just for taking family snaps, but also for recording images of travel to far-flung places. Many wonderful family histories have been recorded by this medium-format camera's relatively simple lens. A very recent camera favourite is the Lomo, a 35mm-format, point-and-shoot compact. Although its controls are limited, it has caught the imagination of those wanting to take spontaneous, good-quality images.

35mm format

In the 1920s an employee of the famous Leitz optical company in Germany developed a new camera format by utilizing 70mm movie film sliced down the middle to give 35mm-sized images. The camera he invented was, of course, the world-famous Leica (short for Leitz camera), a model that has influenced the course of photography.

Many of the best-known photo-journalists have used Leica rangefinder cameras, favouring their unobtrusive size, near-silent shutter, and their ability to accept a range of lenses over the features on offer from more high-tech, larger, and often noisier camera types.

Many people have become interested in photography as a result of using a basic 35mm direct-vision compact camera. For straightforward purposes, these cameras offer the potential for good results. Even though you cannot change lenses, many come with useful zooms, but they make decisions about aperture and shutter speeds you are unaware of and have no control over. For about the same price as a good compact you can buy an entry-level single lens reflex (SLR), and immediately you have a range of exposure options, through-the-lens (TTL) metering, interchangeable lenses, and accurate viewing and subject framing via the reflex mirror and pentaprism.

With an SLR camera in viewing mode (near right) light from the lens enters the camera body where it is reflected upwards by a 45° mirror into the top-mounted pentaprism. From here, mirrored surfaces reflect the light out through the rear eyepiece. When the shutter release button is pressed, the camera is in picture-taking mode (far right): the aperture shuts down to its preset value, the reflex mirror flips up (blanking out the viewfinder), and the shutter opens to allow the light to reach the film or processor. With most film cameras, the film is then wound on ready for the next shot.

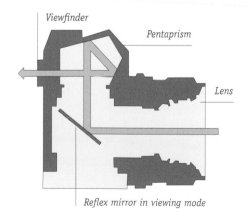

Viewfinder · *Pentaprism* · *Lens*

Reflex mirror in viewing mode

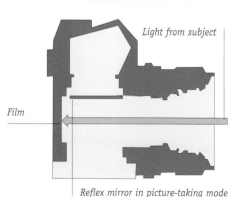

Light from subject · *Film*

Reflex mirror in picture-taking mode

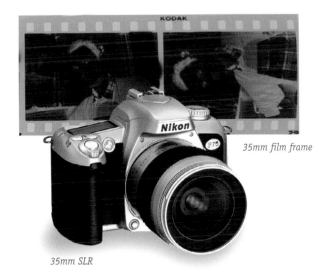

35mm film frame

35mm SLR

M is for Manual. Requires you to set the shutter speed and aperture yourself, according to information from the light meter.

A is for Aperture priority. You choose the aperture and the camera sets the shutter speed automatically.

S is for Shutter priority. You set the shutter speed and the camera sets the aperture automatically.

P is for Program mode. The camera sets both the shutter speed and the aperture.

35mm compact

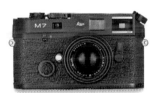

One of the famous 35mm Leica rangefinder cameras

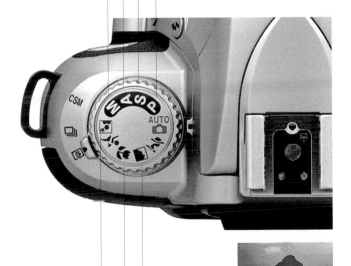

Middle-distance program

Close-up program

Distant program

X or a lightning bolt is the symbol for flash synchronization and, unless an accessory flash gun is attached, any built-in flash will be used if this symbol is selected. If you buy a dedicated flash that relates specifically to your SLR camera, it will automatically monitor light reflecting back from the subject and so prevent overexposure.

Medium format

Medium-format cameras use 120 or longer lengths of 220 film. However, this format includes a range of cameras, both SLR and rangefinder in design, that produce different-sized film originals, but all based on the same 6cm-wide film.

For example, the smallest and most 'compact' design of camera in this format is the 6 x 4.5cm. Next up in size is the square format 6 x 6cm camera, which is a film size made famous by the Hasselblad camera. Then come 6 x 7cm and 6 x 9cm models. There are other, less popular sizes within this medium-format category, the most interesting being the panoramic 6 x 17cm. The larger the area of the film frame produced by each type of camera, the fewer the shots that can be taken on each roll of film.

These cameras remain popular with professionals because their large image size, compared with 35mm (see p. 25), gives excellent results when enlarged. Although smaller 6 x 4.5cm and 6 x 6cm models can be hand-held if reasonably brief shutter speeds are employed to prevent camera shake, all medium-format SLRs lend themselves to being tripod-mounted when in use.

There are lightweight rangefinder models for many of the medium-format camera sizes, and these are an excellent choice for a whole range of photographic situations when high-quality images are essential yet the camera must be hand-held.

Many of the SLR 'system' models have separate film backs that can be replaced with digital-imaging backs.

Large format

This camera format is used only when images of the highest quality are required. Rather than rolls of film, such as 35mm cassettes or medium-format 120 or 220 rollfilm, these cameras use single sheets of film measuring 5 x 4in (12.7 x 10cm), 7 x 5in (17.75 x 12.7cm), or 10 x 8in (25.4 x 20.3cm). Not only does this film size ensure excellent enlargement quality, film processing can also be tailored to suit the needs of each individual image, as each is on a separate sheet of film. With a 35mm cassette or a rollfilm, all images on that film receive identical processing.

Large-format cameras are available in two basic designs – monorail and field models. Monorail types must be mounted on a tripod and

6 x 4.5cm SLR and film frame

6 x 6cm SLR and film frame

6 x 7cm SLR and film frame

are nearly always used in the studio, though they can be used outdoors for static subjects such as architecture and landscape.

Field cameras, though still large, shut down into a box and are relatively easy to carry on location. In appearance, they are similar to the type of press camera used in the 1940s and 50s. Once opened, a lens panel attached by bellows to the focusing screen and film holder slides forward.

Many 'art' photographers work with large-format cameras because of the quality they offer, especially with the current trend towards limited editions of very large (and expensive) colour prints. But even if you never intend to own such a camera, if you ever get the chance to use one, even for a few hours, it is an experience not to be passed up.

Digital cameras

In the main, digital cameras look like their film-camera counterparts, especially SLR and compact models, although there are some unusual designs available – some useful, others simply novel. At present, cost is still the main factor holding back the popularity of the more professional digital SLR formats, though prices are coming down all the time. Special digital backs are available not only for medium-format cameras – there are also large-format studio-camera backs capable of recording images comprising 8,000 x 10,600 pixels, making nearly 85 million pixels, or megapixels, in total. The drawback here (apart from price) is that such an image could take in excess of 3 minutes to record, thus restricting the types of subject they can be used for.

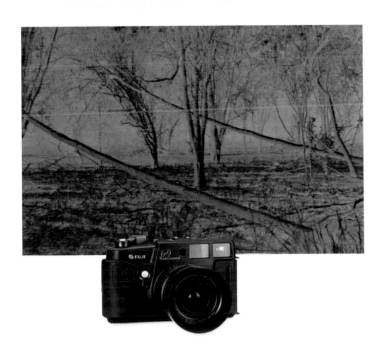

6 x 9cm rangefinder and film frame

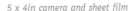

5 x 4in camera and sheet film

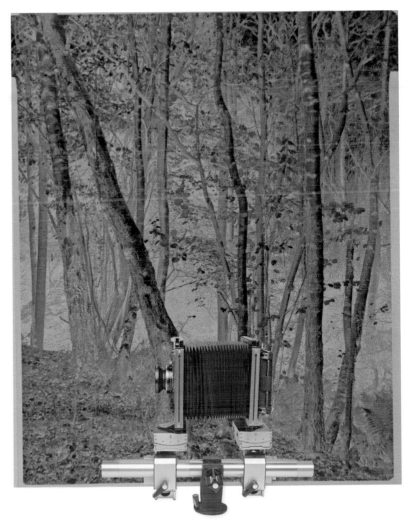

Lens types

The degree of subject enlargement produced by a lens determines the type of lens it is. For example, a 'standard' lens produces a subject enlargement roughly corresponding to our unaided eye, while a telephoto lens produces an enlarged view of a scene, and a wide-angle a reduced view. As the focal length of a lens increases, however, its angle of view, or the amount of the scene it can encompass, becomes narrower and narrower.

TIP

Be careful about dust getting into digital SLR cameras as it can be amplified in the picture. When changing lenses hold the camera body upside down. Some people recommend not changing lenses at all, especially if you have a zoom that covers all your needs.

Digital cameras do not produce a physical image, so there is nothing that can be measured to determine the degree of subject enlargement. Instead, the focal length of lenses for digital cameras is calculated in reference to the image sensor size and is quoted as an 'efl', equivalent

focal length, to the 35mm format. For example, the standard lens for the Nikon D70 6-megapixel camera is about 35mm. The Nikon digital zoom lens of 18–70mm for the same camera is about the equivalent focal length of a 24–90mm zoom on a 35mm camera.

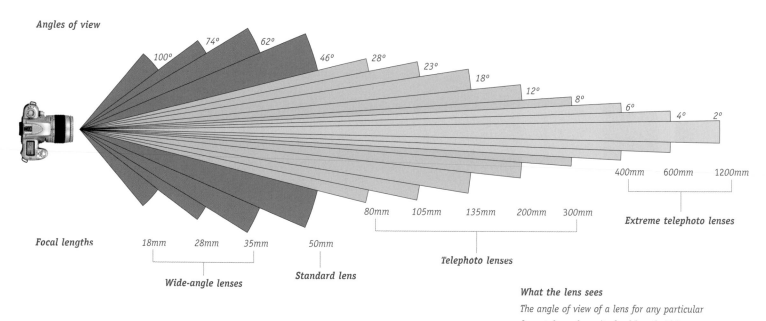

Angles of view

100° 74° 62° 46° 28° 23° 18° 12° 8° 6° 4° 2°

400mm 600mm 1200mm

80mm 105mm 135mm 200mm 300mm

Focal lengths 18mm 28mm 35mm 50mm

Extreme telephoto lenses

Telephoto lenses

Standard lens

Wide-angle lenses

What the lens sees
The angle of view of a lens for any particular format depends on its focal length. This diagram shows the angles of view of a wide range of lenses for the 35mm format.

Focal length

Every time you change lenses or the settings on a zoom lens you produce a different degree of subject enlargement. A 200mm telephoto will give you an image more than seven times larger than a 28mm wide-angle. However, the 74° angle of view of the wide-angle will encompass far more of the scene than the telephoto's mere 12°.

Apart from changing angles of view, using a different focal length lens can produce a very different image perspective. For example, wide-angle lenses tend to open out the different subject planes of an image, so that the foreground, middle ground, and background all appear very distinct and well separated. In addition, a wide-angle lens used very close-up to a subject's face is certain to produce image distortions – enlarging the nose more than the forehead, for example, which is positioned slightly further away from the lens.

A telephoto lens tends to give what is often described as a 'squashed' perspective, resulting from the fact that the background is enlarged in relation to the foreground and so appears to bear down on it.

Zoom lenses have variable focal lengths, most often within the range 28–80mm or 80–200mm. Some zoom lenses bridge the wide-angle and telephoto categories with focal length ranges of approximately 28–200mm.

Wide-angle perspective

A wide-angle lens (above right) imparts a particular look to a photograph. Foreground elements appear enlarged compared with more distant parts of the subject and the image planes (foreground, middle ground, and background) look well separated.

Telephoto perspective

A long lens produces this typically 'squashed' perspective, with the background bearing down on the foreground.

Autofocus problem

Most autofocus systems favour the centre of the screen. As you can see in this image, the lens has focused on the background and rendered the real subjects as a blur.

Autofocus solution

With an off-centre subject, move the camera so that the subject is centre frame, focus the camera (usually by half depressing the shutter-release button), lock the setting, and then recompose the picture before shooting.

Lens 'speed'

Lenses are often referred to as being 'fast' or 'slow'. The speed of a lens depends on its widest aperture setting – the wider it is, the faster the lens is said to be. For example, a lens with a widest maximum aperture of f2.8 is slower than a lens with a widest maximum aperture of f1.2 or f1.4. The design of fast lenses is difficult, especially if image quality is to be maintained, and this is reflected in the price.

There are two principal advantages in having a fast lens. First, a wide maximum aperture allows you to shoot in low light conditions while using a conveniently brief shutter speed. If your lens opens up to only f5.6 (common with many telephoto zooms), you might have to use a shutter speed of ⅟₃₀ sec to achieve the correct exposure in some conditions. In those same conditions, a lens with a maximum aperture of f2.8 would allow you to use ⅟₁₂₅ sec.

The second advantage of having a fast lens is that with SLR cameras the brightness of the image in the viewfinder depends on the speed of the lens – the wider the maximum aperture, the brighter the image you see to focus on.

Manual or autofocus

Many cameras have a switch that changes focus from automatic to manual. In autofocus mode a motor in the camera moves the lens in and out until it determines the subject is in focus. This is useful if you need eyesight correction but find glasses difficult to wear when using a camera. But there are problems. For a start, you need to know where the system assumes the main subject will be in the viewfinder, because that is where it focuses the lens. If your subject is, say, off-centre (most autofocus systems assume the subject is approximately in the middle of the frame), then you may get a wonderfully clear image of the background and an out-of-focus foreground subject off to one side (see left).

Another possible problem arises when shooting through a window – some systems may focus on the glass rather than the scene beyond.

The third potential problem with autofocus systems is noise – the motor can be noisy when moving the lens back and forth, making them unsuitable for some wildlife photography or when you don't want to draw attention to yourself or to the presence of the camera.

Zoom lenses

While it is possible to find fixed focal length lenses for every need, many people favour zoom lenses, whose variable focal lengths cover a range of settings. The wider the range of focal lengths covered, the more difficult it is to maintain image quality, especially at the extremes of the zoom range.

28-70mm zoom

80-200mm zoom

28-200mm zoom

200-400mm zoom

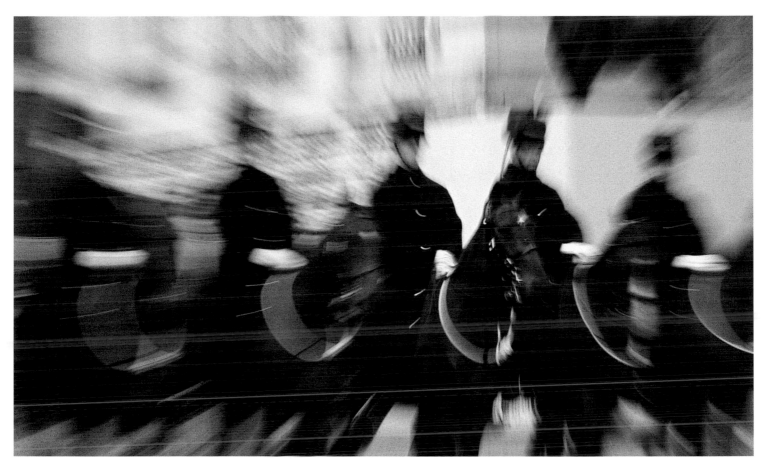

Zoom movement
By setting a reasonably slow shutter speed – say, about 1/15 or 1/30 sec – and zooming the camera lens while the shutter is open, you can produce explosive-looking images even when the subjects are completely static. Try to keep the camera as steady as possible so that camera shake does not mar the effect of the zoom movement.

Specialist lenses

When extreme close-up photographs of exceptional quality are required, special macro lenses are available. These lenses are expensive to buy, but they have been designed especially to give their best results when they are focused far closer to the subject than would be possible with non-specialist lenses.

The problem of converging verticals is something most photographers encounter at some stage. This occurs when the camera is tilted upwards to include the top of a tall building or monument. Using a PC (Perspective Control) lens you can keep the camera (or, more importantly, the film or sensor) square-on to the subject while shifting the lens elements up to 'slide' the top of the subject into view. As with macro lenses, PC lenses are too expensive to buy unless your work demands them, and it might be better to consider hiring a lens of this type for occasional use.

Fisheye lenses are extreme wide-angles – so extreme, in fact, that they can give a circular, 360° view (thus including yourself taking the picture in the frame). It is hard to image anybody wanting to use this type of lens very often, so you must decide if the expense is justified.

Lens filters

The most commonly used lens accessories are filters. These are placed over the front element of the lens, thus affecting all image-forming light reaching the film or camera sensor. Filters fall into a variety of categories: some are designed specifically for use with black and white film; some are intended to make subtle colour corrections when using colour slide or print film; while others are intended to produce a range of special effects, ranging from the subtle to the bizarre.

General-use filters

Many photographers, working in colour and black and white, leave a colourless UV (ultraviolet) filter permanently on the lens. This filter has no effect on exposure but does (to some extent) cut through the type of hazy light often found in coastal regions or at altitude. In addition, the filter is inexpensive to buy and protects the delicate front element of your lens from dirt or abrasion. Polarizing filters (like sunglasses) are used to cut out reflections from glass or water and to improve the appearance of skies by increasing colour saturation.

Special effects filters

There are dozens of special effects filters to try, ranging from the sometimes useful soft-focus, graduated colour, and starburst filters through to those that heavily distort and fracture the image or give multiple, repeating, or kaleidoscopic effects. The best advice here is to think carefully before using filters that have too much 'presence', as you are likely to tire of them pretty rapidly.

Conversion/correction filters

Colour conversion filters, like the blue 80 (A, B, C, D series), allow film (principally colour slide film) that is designed to be exposed under daylight conditions to be used in tungsten lighting; the amber 85 (A, B, C, D series) allows you to use tungsten-balanced film under daylight conditions (see pp. 56–9). Several types of magenta filter are suitable for correcting the green cast from fluorescent light on daylight-balanced film. The 81 (A, B, C, D) warm-up filters eliminate any slight blue coldness in the shadow areas of some films. Neutral-density filters reduce the total amount of light entering the lens without affecting its colour content. They are available in 13 densities and are used most often to prevent film overexposing in very bright conditions.

Filter factors

Unless they are extremely pale, all coloured filters prevent some light from reaching the film or sensor, requiring an adjustment to exposure to be made. The amount of adjustment needed is known as the filter factor, which you will find engraved on the filter mount. A pale orange skylight filter may, for example, require just a ½ stop extra exposure, while an orange filter may require 2 stops extra. The amount of exposure compensation a polarizing filter requires varies as you rotate the filter on the lens.

As most cameras today feature TTL (through-the-lens) exposure metering, any fall-off in light is usually detected and automatically compensated for. If you are using a separate hand-held exposure meter, however, you will have to set the compensation manually.

Filters for black and white

The filters most often used in black and white photography are yellow-, orange-, and red-coloured discs of glass or squares of gelatine. Although the film is black and white, the emulsion is still sensitive to all the colours of the spectrum, producing different tones in response to each. These coloured filters lighten tones corresponding to their own colour and darken those of the opposite colour.

So why use them? A yellow filter is useful for landscape work, lightening yellows and darkening anything blue, so emphasizing white clouds by making the surrounding blue sky appear a darker tone. An orange filter lightens tones corresponding to orange and darkens the tones of green and blue, making it useful for emphasizing the tonal variations in in wood, for example. A red filter has the strongest effect, lightening red and darkening cyan, which is a mixture of green and blue light.

The red filter is sometimes called a night-for-day filter because if you underexpose the film by about 2 stops with this filter over the lens, bright daytime scenes take on a moonlit appearance.

TIP

Keep all filters clean. Scratches or dirty finger marks will affect the sharpness of the image.

Colour version for comparison

No filter

Yellow filter

TIP

Don't put too many filters on the lens at the same time (especially on a wide-angle) – the combined thickness of their mounts can stand so proud of the lens that a slight vignetting of the image occurs.

Orange filter

Red filter

Film types

Your eyes can adapt to most changes of light, but film does not, as it is made to work best under particular conditions. Choose the correct film for the lighting situation and you will get good results.

People are drawn to black and white film for its graphic qualities, its tonality, and its texture (see pp. 54–5) Colour negative films are general-purpose in nature and the favourite choice of amateur photographers as they are inexpensive, and prints, in a range of sizes, can be easily produced from them. Colour slide, or transparency, films are the choice of most film-based professionals. Colour rendition can be superb and they reproduce well in books, magazines, and other publications. Digital cameras, of course, use a memory card rather than film.

General black and white

The standard panchromatic film emulsion is sensitive to the entire spectrum of colours and produces tones in response to each. Film speeds vary from 25 to 3200 ISO. Speed in this context refers to a film's sensitivity to light – the more sensitive it is, the higher its ISO (International Standards Organization) number. A doubling of film speed – from, say, 200 to 400 ISO is the equivalent of 1 stop of exposure. For example, instead of using f8 at $\frac{1}{125}$ sec with 200 ISO film you could use f8 at $\frac{1}{250}$ sec with 400 ISO film (or f11 at $\frac{1}{125}$ sec) and achieve the same overall level of film exposure.

Differences in film speed are accompanied by differences in grain response. Grain in black and white emulsions is the visible appearance of the silver halide crystals that darken in response to light to make up the image (in colour film, it is more usual to refer to clouds of dye rather than clumps of grain). Slow films give fine grain as well as an extended tonal range, but they have little shadow detail. Because they are slow, these films need good light or a tripod-mounted camera for long exposures. Medium-speed films, about 100 or 125 ISO, are also fine grained, but the extra speed (100 ISO is 2 stops faster than 25 ISO) makes them easier to work with.

For hand-held pictures in daylight, 400 ISO is the preferred general-purpose film. It is perhaps, depending on taste, a little grainy for work with studio flash, and it does give excellent shadow detail. 1600 ISO is a high-speed film and, despite its grain, is a favourite with some photographers for giving moody portraits. 3200 ISO is the film to choose if you need to hand-hold the camera in low-light, but its grain response is very evident.

High-speed 3200 ISO film

Fine-grain 100 ISO film

Most film companies produce traditional silver-based films, but Ilford XP2, Kodak CN, and Fuji CN films are unusual as they can be developed in C41 (the developer used for colour negative films). This is because these are dye-based, like colour films, rather than silver-based.

Specialist black and white

Ilford Ortho is an orthochromatic black and white film that is insensitive to red, so anything in a scene coloured red will reproduce as black. It is very fine grained and, if processed in normal-strength developer for the standard time, it is extremely high contrast, producing only black and white tones (with no mid-tones). If the film is processed in a weak solution of developer, you get a normal range of tones and fine grain.

Kodak Technical Pan is a very fine-grain film and is available for all camera formats. Because of its slow speed, it is most often used in tripod-mounted cameras. It needs to be processed in its own developer for optimum results.

Infrared film not only records the normal spectrum (as seen by panchromatic film), but its sensitivity extends to infrared wavelengths of light. Kodak make a high-speed 35mm infrared

film that gives a strange effect in normal daylight scenes. For example, although invisible to our eyes, the chlorophyll in plant leaves strongly reflects infrared light, which appears as a ghostly, glowing white once printed.

Instant-picture film was a popular breakthrough in its time, and it also proved useful for professionals needing test pictures before committing themselves to a final film version in the studio or out on location. Though not so popular now as an amateur film, its professional role is also being threatened by digital imaging, which allows you to see the results of a shot instantly.

Colour

Today, the range of colour films is simply huge. For use in daylight conditions or with flash, Fuji, Kodak, and Agfa have transparency films ranging from 50 to 400 ISO, and daylight colour negative films from 100 to 1600 ISO. For use in tungsten light there is 64T, 160T, and 320T slide film (see also pp. 56-9).

Because colour negative film has a printing stage where some exposure errors can be corrected, you have a fair degree of exposure latitude at the time of taking the pictures. With

slide film, however, once the film is developed that is the final image, and the emulsion allows you little margin for error.

Digital

With digital cameras, the 'speed', or sensitivity, of the sensor can be altered shot by shot, but bear in mind that the higher the sensitivity of the sensor, the more electronic 'noise' it will record. If you like, noise is the electronic equivalent of film grain. Another choice you need to make with digital is the file size of each shot you take. This is important as it determines the quality of the final image. For example, the JPEG Fine file format takes up much more space on the memory card than the file format designed for 'saving for the web'. JPEG is the standard compression for digital pictures, but by recording in the RAW file format you retain the maximum amount of information and so give yourself the greatest flexibility when working on the picture on the computer.

There are different types of memory cards, some specific to certain cameras, others able to be used in a range of different models. Cards also vary in their memory size and the price increases with the amount of memory.

Ultra-fine-grain 25 ISO film

High-speed 1600 ISO film

Flash

Many SLR, rangefinder, and compact 35mm and digital cameras have a built-in flash – forward-pointing, simple to use, but limited in its output and effectiveness. This form of supplementary lighting is useful for photographing family and friends in informal situations, as long as the main subject is quite close to the camera. However, direct flash is a contrasty and stark form of lighting, and although it has the correct colour temperature for daylight (see pp. 56–7), its limitations must be recognized.

TIP

Diffuse direct flash with tissue paper over the flash tube, or buy a special plastic attachment that fits over the flash head.

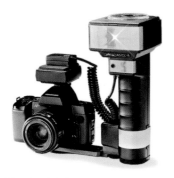

Candlestick style of flash unit. Note that synchronization is still through the camera's hot-shoe.

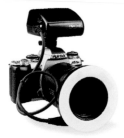

Ring flash surrounds the front of the lens and delivers shadowless lighting for close-up subjects.

Hammer-head style of flash unit.

Built-in flash automatically synchronizes with the correct camera shutter speed (see p. 25), and so requires no action on your part. Some add-on, or accessory, flash units that fit into the connector (known as a 'hot-shoe') on top of the camera's pentaprism automatically engage with the shutter for correct synchronization. If you are in any doubt, check your camera's instruction book and, if necessary, manually set the correct shutter speed. Cameras with leaf shutters, also known as between-the-lens shutters, commonly found on medium-format types, synchronize with flash at all shutter speeds.

Guide numbers

The guide number of a flash unit is a measure of how powerful it is in relation to other flashes. With a standard film speed setting of 100 ISO, the maximum distance in metres that the flash will illuminate is indicated by its guide number. A basic, entry-level flash will have a 10m (33ft) maximum range (assuming the flash is fired indoors with a certain level of reflective surfaces), whereas with a more powerful flash the maximum range could be 50m (160ft). However, most flash subjects will be well within 3m (10ft) of the camera, allowing you to reduce the amount of light reflecting back from the subject and reaching the film by selecting a smaller aperture and so increasing depth of field (see pp. 16–19).

Accessory flash

The commonest type of accessory flash is the 'hammer-head' design that fits into the camera's hot-shoe. Many can also be linked to the camera via a flash-synchronization cable, which allows you to hold the flash above, below, or to one side of the camera for more varied lighting effects. These flash units also have swivelling and tilting heads to allow you to bounce flash light from walls or ceiling (though watch out for colour casts if the reflective surfaces are strongly coloured).

When using these flash units, make sure that the flash light sensor is always pointing at the subject. This piece of circuitry monitors the light coming back from the subject and automatically halts flash output once correct exposure is achieved. This system is not infallible, but will often prevent overexposure. What it cannot do is alleviate underexposure if the subject is out of range of the flash output.

The main camera manufacturers make their own flash units dedicated to their camera systems. Independent flash makers also make units specifically for particular cameras as well as units that will work with any camera with the correct connector.

As well as hammer-head flash, candlestick types are also available. These are usually more powerful and are side-mounted on a bar that screws into the tripod bush on the camera baseplate.

Ring flash

When shadowless lighting is required for close-up subjects (see pp. 120–1), ring flash is the preferred choice of lighting of many professionals. This type of flash is very different in design, as the flash tube sit at the front of the lens and gives a circle of soft, shadowless light. An inexpensive unit might have a guide number of about 5m (16ft), but this is no problem as your subject is likely to be very close to the camera.

Studio flash

Studio flash heads are much more powerful than accessory flash units and their light output can easily be varied. These lights are most often, as their name implies, used in the studio, but lightweight, self-contained versions, known as monobloc lighting heads, can also be taken out on location.

A general-purpose flash outfit could consist of two or three flash lighting heads with their stands and connecting cables, special flash umbrellas to give reflected light, and a soft-box to diffuse and soften light output. There is a choice of umbrellas – from basic white, which reflects a soft light, to silver, which gives a more contrasty light and adds a stop more to the flash meter reading.

Additional accessories include a honeycomb, which creates a circle or spot of light; different reflector bowls, to alter the amount and angle of reflection; and a spot attachment that fits over the flash tube when a very directional light effect is needed.

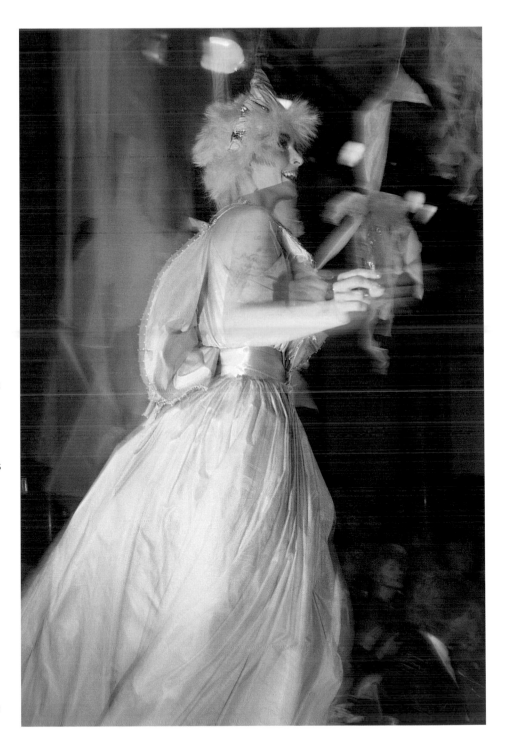

Flash and blur

This picture was taken using flash with a slow shutter speed. While the shutter was open, there was enough light in the room for the subject to record as a blur, but when the flash fired it recorded a sharp secondary image of the subject on top of the existing one.

General accessories

Accessories should help you achieve your photographic ambitions, not get in the way. Don't get bogged down with equipment you don't really need – carry only those items you are likely to use. The best advice is travel light so that nothing comes between you and the picture. Professionals often take extra equipment to cover themselves for any eventuality – no problem if you have an assistant and are shooting for a specific job.

Hand-held spot meter

Camera bags

The camera bag is one of the most important accessories to consider. It has to be weather- and dustproof and have strong zips so nothing can fall out. You can hang some bags over one shoulder, which is fine if the weight is not too great, while others are designed to fit over both shoulders, which might save you back problems.

Hard cases should have internal divisions you can change around to suit your equipment. Tough reinforced or aluminium cases are used by professionals as they are often taken abroad and have to go through airport handling. These cases can even be stood on to gain a little extra height when taking a shot. Soft bags are lighter and, with internal padding, give good protection.

Grey card

Kodak make an 18% reflectance grey card as an aid to exposure. You hold the card up in front of your subject and take a light reading from it in order to determine the correct exposure for the mid-tones of the whole scene.

Light meters

For general, reflected-light readings the camera's built-in TTL (through-the-lens) meter can usually be relied on to give accurate results. Sometimes, however, there may be a small though crucially important part of a scene for which exposure must be correct. In such a situation, you can use a separate 'spot' meter to take a light reading from

that one, specific part of the scene. Such a meter will have only a 1° angle of view, which allows you to fill its receptor area with a tiny part of the subject and so is excellent for taking very precise readings. Some TTL meters are also spot meters, taking only the small central area of the viewing screen into account when calculating exposure settings.

Another type of hand-held meter does not measure continuous light (i.e. daylight); instead it is designed to register the extremely brief light output from a flash. Good flash meters are accurate to about $\frac{1}{10}$ of a stop, which should be more than you need.

Batteries, film, memory cards

Don't forget to take enough batteries with you, especially if you are shooting in a location where camera shops are few and far between. If travelling, take a battery charger as well. Film is not expensive compared with most other aspects of your trip, so work out how much you are likely to use and add in a few extra rolls.

Digital photographers may find a laptop or some other form of mobile hard-disk useful for downloading images to free-up memory cards, but take ample spare cards as well.

Hard case with adjustable internal divisions

Lightweight soft camera bag

Fully adjustable backpack-style camera bag

Tripods

A good tripod gives you more options in your choice of pictures. When hand-holding a camera you need to use a shutter speed of at least ¹⁄₆₀ sec to be sure to avoid camera shake, but mount the camera on a tripod and you can use shutter speeds of many seconds in the right conditions without a hint of a shake. Tripods attach to the camera via a screw bush on the camera baseplate

On location

With a tripod, night photography suddenly becomes possible and you can attempt starlight exposures that could take hours to complete. But many people use a tripod for stability even in good daylight when extremely small apertures are called for to give maximum depth of field. At, say, f22 a shutter speed of ¹⁄₁₅ sec or slower would not be unusual. Some tripods have spikes on the ends of the legs to increase stability on soft ground. They also have rubber cups to cover the spikes for use indoors. Look for a lightweight tripod for location work, but one that does not compromise stability. All tripods have extendible legs, and some can have legs that extend sideways to give stability on slopes.

Indoors

Indoors, or in a studio, the extra weight of the tripod is not such an important factor and so you can go for the heaviest model your budget will allow. Studio tripods have a centre column that can be cranked up and down to adjust the height of the tripod head and camera. They are suitable for all formats of camera, but are most often used with medium-format and larger models because of their weight.

Different heads

Professional-style tripods have interchangeable heads to which the camera is attached. Some photographers prefer a simple ball-and-socket head, which can be swivelled to nearly any angle and then clamped in place. Another commonly used type is a pan-and-tilt head, which can be locked to stabilize the camera firmly in any position or, with a twist of the handles, give the camera free movement to follow a moving subject. Some heads also have a built-in spirit level to check that the camera is dead level.

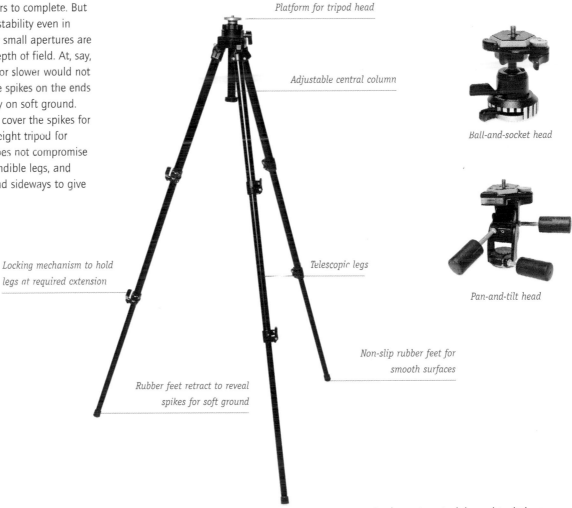

Platform for tripod head

Adjustable central column

Ball-and-socket head

Locking mechanism to hold legs at required extension

Telescopic legs

Pan-and-tilt head

Rubber feet retract to reveal spikes for soft ground

Non-slip rubber feet for smooth surfaces

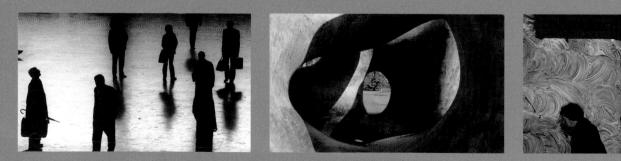

Photographic seeing

Composition

Composition in photography is distinctive, as you are taking pictures through a single lens, and have a one-point perspective. Your normal vision is stereoscopic and so is quite different from the single, monocular eye of the camera. Photographers sometimes shut one eye and squint at the subject to see how the scene might look to the camera.

When thinking about photographic composition, it might help to regard the borders of the viewfinder frame much as an artist thinks of the defined boundaries of the canvas or sketch pad. Within the available space the main subject elements need to be arranged to give them a prominence that encourages them to be viewed as intended, while ensuring that the less important elements within the composition are seen in a supporting capacity. In most cases, therefore, without the painter's artistic licence to show the scene in some idealized fashion, the most important compositional device at your disposal is the shooting position you adopt.

Also at your disposal, however, is the camera's ability to record shape, form, tonality, abstraction, and textures in a variety of ways to create images of ambiguity, images that challenge the assumption that the camera records reality in a purely straightforward and mechanical way. The selective eye of the camera allows you to come in close to a subject, for example to remove unwanted clutter. Your choice of exposure settings can strengthen or weaken colour relationships or tonal balances within the scene, so emphasizing some areas of the frame over others. And your choice of focal length can open out the foreground, middle ground, and background for a light and airy composition or close them down to create an air of confinement.

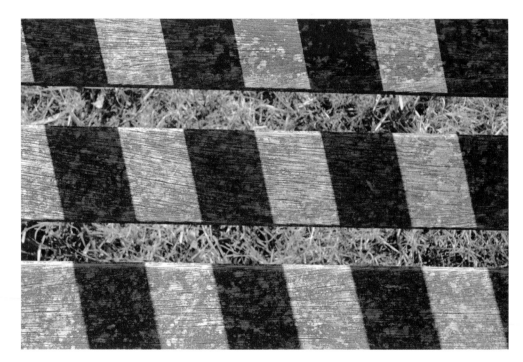

A narrow view

Here the photographer has moved in close, using the narrow angle of view of a long lens to show a segment of a sunlit bench. This abstract composition comprises horizontal bands of weathered wood with narrow strips of strongly coloured grass showing between. Overlaying it all, adding its own abstract qualities, are the diagonal bands of shadow cast by some unseen obstruction.

The Golden Section

Over the millennia, formalized rules of artistic composition have been devised to divide areas of the frame into what are considered to be pleasing proportions. The Golden Section illustrated here is one of these and has been influential not only on composition in art but also on architecture. The Parthenon in Athens, for example, was built to the Golden Section, and the twentieth-century French architect Corbusier used it to develop his Modular theory, which he applied to the design of furniture and interiors. And because the Golden Section is based on a rectangle figure similar in its proportions to the 35mm format, it can also be considered an aid to photographic composition.

In essence, a rectangle is devised so that when a square is constructed within it, Z (the overall length of the figure) is in the same ratio to X (the side of the square) as X is to Y.

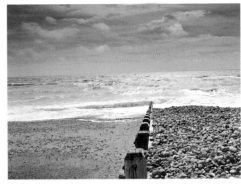

Geometric harmony

In this view of a shingle and sand beach, an arrangement of space has been created by applying the principles of the Golden Section to divide the scene. Although it is unlikely that anybody would want to be overly precise in ensuring exact conformity, the ratio of sand to shingle does produce a sense of harmony.

Division of Thirds

Another way of organizing the frame in order to create points where subject elements have particular compositional significance is known as the Division of Thirds. In this system, imagine that the picture area is divided up into thirds by lines running both horizontally and vertically. It is suggested that anything positioned on these horizontal and vertical lines will be emphasized within the composition. However, even more prominence will be given to subject elements positioned where any two of these lines intersect.

Compositional rules are, however, meant to be broken, and as often as this system seems to work, other pictures will always come to light to prove it wrong. Often, for example, a centrally placed subject forms the lynch pin for a composition, while objects positioned in conformity to the Division of Thirds are relegated to mere walk-on parts.

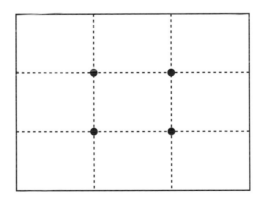

Leading the eye

The Division of Thirds can be seen at work in this composition. The subjects take up a large area of the frame, but of the three figures it is not the centrally positioned one that appears most prominent; rather, it is the right-hand figure occupying two of the imaginary intersection points that most immediately attracts the eye.

Perspective

Perspective in photographs helps to introduce depth and distance into the two-dimensional frame. There are many indicators of this, including diminishing scale, converging verticals, aerial perspective, and overlapping forms. In addition, by using a shallow depth of field (see pp. 16–19) to render some subject elements less sharp than others, you can imply that they are at different distances from the camera.

Diminishing scale and converging verticals
In this photograph it is easy to see how the distant trees in the arched avenue appear smaller in the frame than those nearer the camera, even though we know they are all about the same height. The way that the parallel sides of the track converge is another strong indicator of depth and distance.

Aerial perspective
The aspect of perspective known as aerial perspective is evident in distant, often mountainous landscapes, and is caused by the presence of ultraviolet (UV) light. UV light has a tendency to cause colours to shift towards blue as they recede from the camera. In black and white photography, UV light causes tones to lighten towards white as they recede. The effects of UV light can be lessened by using a UV filter over the lens, if this is desired. As you can see, however, the effect can be very evocative.

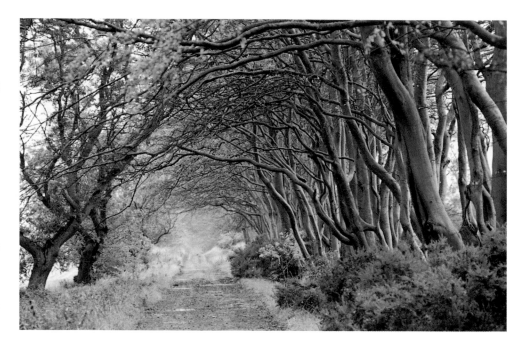

Overlapping forms

We know from our experience of the real world that when objects overlap, one must be further away than the other. This makes overlapping forms another indicator of depth and distance in the frame and you can either emphasize or minimize its effects by selecting the angle to shoot from.

TIP

If you find an interesting subject to photograph, don't just take pictures from the first spot you find. Explore the subject and take several pictures from a variety of angles - treat the camera as a sketchbook and edit the results later.

Positioning the horizon

Where you position the horizon in a photograph can have a profound effect on the atmosphere generated. A centrally positioned horizon in a landscape (near right) is probably the most neutral position of all. Here, neither the land nor the sky is given particular prominence. By moving the camera downwards (far right, top) you include more of the foreground in the frame. Immediately the image takes on a more confined, claustrophobic feel as the presence of the sky is minimized. Moving the camera upwards to lessen the amount of foreground (far right, bottom) has the effect of opening out the landscape, brightening and lightening the scene as more of the sky slips into view.

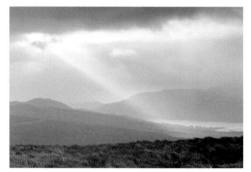

The camera's eyeline

Photographic composition has everything to do with how the camera is positioned in relation to the subject, and the eyeline the camera creates is crucial to the way the picture is viewed. Here, the camera lens is looking directly through this Henry Moore sculpture and so the eyeline draws you right into the work of art and, by extension, into the picture itself. The view at the end of the 'tunnel' is sympathetic in colour but has no particular feature to hold your attention and so there is nothing to distract you from the sculpture itself.

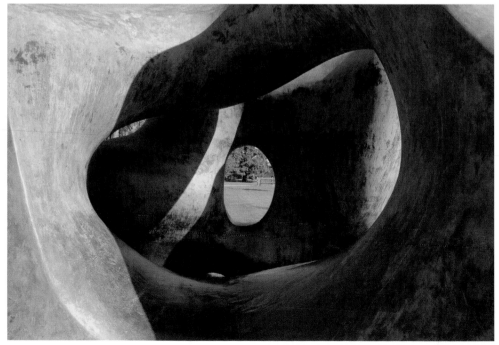

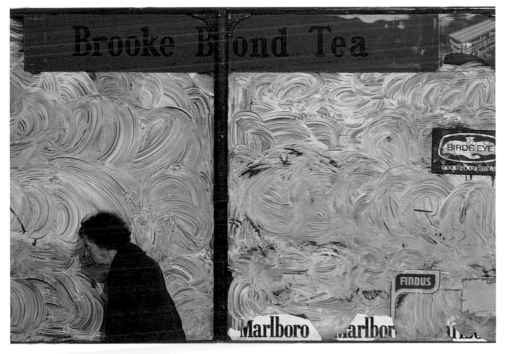

Unsymmetrical composition

Placing what most people would assume to be the main subject – a human figure – well off to one side of the picture area produces an unsymmetrical composition. However, the light tone of whitewashed window, which dominates most of the scene, is perfectly balanced by the dark tones of the woman's hair and coat, even though they take up very little of the frame. Note, too, how the strong, dark line of the window frame divides the frame into proportions roughly corresponding to the Golden Section (see p.43).

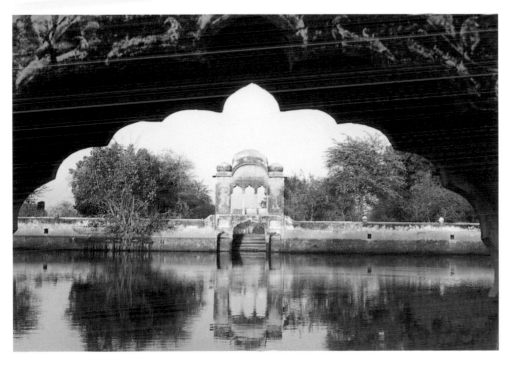

Symmetrical composition

The formality of this Indian scene and the series of repeated shapes in the foreground archway demanded a central camera position. The symmetry of the composition is emphasized by the distant trees growing either side of the steps leading up to the tall gateway. Even the reflections in the water add to the symmetry of the scene.

The decisive moment

The famous French photographer Henri Cartier-Bresson coined the now well-known phrase 'the decisive moment' to express his philosophy of picture-taking. He liked to photograph life in the streets, with people moving around doing ordinary, everyday things. He was an expert at capturing that special moment when small incidents occurred, and he had the skill to record them in interesting ways, with a faultless eye for composition, with technical perfection, and often with wit and humour.

There is a French tradition of reportage involving such photographers as Robert Doisneau and Willy Ronis, but the most famous of all is Cartier-Bresson. He started taking pictures in the 1930s, and his street scenes, with their strange juxtapositions, ambiguity, and graphic shapes, were strongly influenced by the Surrealists. The invention of the unobtrusive, light, and easy-to-use 35mm Leica rangefinder camera in the 1920s was an enormous influence on his style of work.

Timing

Taking pictures of action needs a sense of timing – the wrong expression, someone blinking, or squeezing the shutter release after the ball has been struck can spoil a picture. Every photographer has a story of 'the one that got away', with the picture of a lifetime occurring a second before or after the one they took. Most often, a brief shutter speed of at least $\frac{1}{125}$ sec is necessary to freeze the action. You also need to be able to predict what is about to happen so you can be in the right place at the right time.

Think about how your subjects relate to their surroundings so that you can frame them to best advantage, and be prepared to move around to get the best composition and angle. If you like a particular background – perhaps a store front, billboard, or street corner – then you could find a good position and wait and observe until something interesting happens in front of it.

You have to be patient with this approach to photographing a subject, as it doesn't come easily. But when it works, the effect is brilliant and it looks effortless.

Patient rewards
When the sun is at its hottest, lions take it easy. Even so, a 350mm lens was necessary to provide a safe shooting distance. A second or two after this shot was taken the mood changed and these two males started scrapping. They kicked up so much dust that it was impossible to see what was going on.

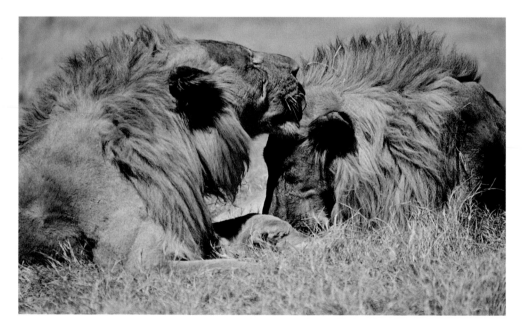

Technique

The 35mm and small-format digital cameras are the easiest to use for this type of photography, though you need to make sure that shutter lag is not a factor – any delay in the shutter firing could be disastrous for the decisive moment. Unless the subjects are engrossed in their own activities you may need a long lens to allow you to hang back unnoticed. A lens around the 135mm mark is not too heavy and will give a decent degree of subject enlargement. Sports or wildlife photographers often use very much longer lenses than this, however – 500mm or even 1000mm lenses are not uncommon and these optics are so heavy they must be supported to avoid camera shake. With less extreme lenses, using a fast film (see pp. 34–5) may allow you to select a shutter speed brief enough to prevent camera shake.

Photographing people in a candid, reportage style can be achieved using a standard or wide-angle lens when the subject is aware of you being there, but has no objection. I prefer this approach as pictures tend to look more natural, but you have to sense how close you can get to the action before the presence of the camera starts to influence what is happening around you.

Empathy

An understanding of your subject and the activity you are covering can be a great help when it comes to capturing the decisive moment. If you have played a sport before, for example, or you are a fan, then you will be looking for the significant moments of the action. Dance or theatre photographers recording a rehearsal will get better pictures if they know the dance or play well and can anticipate the important parts of the production. Newspapers and magazines are full of pictures of arts productions or moments in sporting matches caught brilliantly.

Wildlife photography is easier if you know something of the animals' behaviour patterns, and can predict where they might be at particular times of the day. Lions, for example, don't normally hunt in the heat of midday and so you are more likely to capture moments of family routine if that is when you go out with your camera. Likewise, if you know your subject well, you might stake out a particular tree where a bird of prey habitually alights before returning to its nest with a kill. You need huge patience for wildlife photography and, as the saying goes, 'you create your own luck'.

Visual elements

The ingredients that make up a visually arresting photograph include such subject qualities as texture, form, shape, tonality, and colour. These could be described as being key components of the design or graphic content of the picture, and to take reliably good photographs it is important to know how to use them to best effect.

Texture

This quality of a subject is brought out particularly well in black and white photography, when the distraction of colour is removed. Texture is most readily apparent when sidelighting emphasizes the surface features of the subject, as you can see represented in the diagram below. It is the way you show the structure and detail of objects that is most influenced by the quality of the lighting. Hard light emphasizes the appearance of texture by creating minute areas of highlight and shadow, while soft light tends to fill the surface of the subject with light and so subdues the appearance of texture.

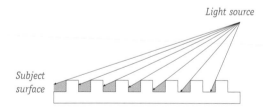

Texture and lighting
Surface texture becomes apparent when light illuminates the tiny high points on the surface of the subject, throwing shadows into the tiny troughs. The more angled the sidelight, the greater the contrast between highlights and shadows.

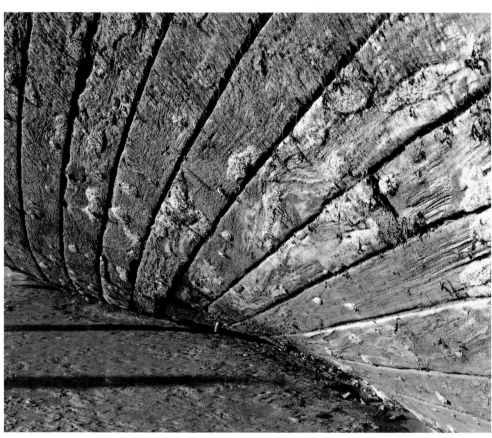

Texture and character
The countless nicks and scrapes, pits and gouges in this boat's keel create a composition in which textures tell the observer all that is important to know about the subject.

Shape and form

The two attributes of shape and form are crucially important visual elements in photography. Shape is fundamental to our everyday experiences, and quite often we instinctively recognize people we know, even casual acquaintances, simply by their shape alone, long before we can see any facial features or other clues to their identity.

Shape is more pronounced when the colour or tone is even. As you can see in this photograph of wooden buildings (left), where the shadow is heaviest and the tone even the woodwork seems at its most two-dimensional, and so shape is strongest. As your eye moves up the building, however, daylight starts to creep in around the area of the eaves. Once the play of light and shade is involved, we see more of an impression of the building's form and, as a result, we begin to know what the structure is like as a three-dimensional object.

Tonality

The tonality within a subject is determined by the quality of the light falling on it – a soft, or low-contrast, light provides you with the opportunity to record an extended range of tones, with subtle variations in the mid-tones. Hard, or high-contrast, light produces a shorter tonal range – blacks and whites are present but not many mid-tones.

In what are known as 'high-key' pictures, light tones or colours predominate, perhaps with areas of white, and there may be a light-hearted response generated in the viewer. In a 'low key' picture, the tones or colours are generally dark and, consequentially, more of a sombre mood is likely to be generated.

There is a resonance between tonalities, as in musical notes: light against dark, or grey against white (see also pp. 54–5). Try to think of the balance of tonalities within a subject or scene when composing the shot.

High-key subject

To take a picture in which light tones or colours predominate, find a light-toned subject and then add 1 or 2 stops of exposure to the normal light reading in order to lighten the result even further.

Low-key subject

To create a low-key composition, select a subject in which dark tones or colours predominate. Then reduce the normal exposure reading by 1 or 2 stops.

Colour

When we view a scene, our eyes take in all the information before them, but our brain acts as a filter, toning down or lifting colours and registering or failing to notice subject elements according to our likes and dislikes, preferences, and prejudices.

When working with colour film, however, you click the camera shutter and everything is registered objectively. That colour clash between the garish red dress and the green curtains in the background you failed to notice at the time of shooting is faithfully recorded, but that subtle combination of beige and pastel shades of blue you liked so much on the walls seems somehow swamped by the other content in the scene when you see the pictures. So it falls to you to ensure that the camera records the scene from the right angle, at the right height, and in the right light to make the best composition and convey the appropriate mood and atmosphere. You can't regard colours as something merely incidental – they are the very building blocks of the image.

When colours are arranged on a colour wheel (above right) in the same order as they appear in the colour spectrum, you can see why the reds through yellows are said to be 'warm' colours, while the greens through blues are said to be 'cold'. You can use these colour attributes to convey particular moods in a photograph simply by framing or cropping a scene to ensure that the appropriate colours predominate. You can also use colour to suggest depth and distance in a picture, as warm colours tend to appear to advance towards the viewer, while cold colours appear to recede.

Colours have such important and emotive qualities that every culture has imbued them with significance. In most of the Western world, for example, black is the colour of mourning and white the colour of weddings and purity. In China, however, white is the colour people traditionally wear for funerals and in Hindu India red saris are worn for weddings.

Colour wheel

Colours that come from the same area of the colour wheel tend to harmonize when used together, a harmony that increases as colours lighten towards white. Hues well separated or opposite each other on the wheel form colour contrasts when used together. Colour formation in photography (using light) differs from that in painting (using pigment). The primary colours of light are red, green, and blue; mix any two of them together and you get one of the secondary colours, magenta, cyan, or yellow. Mix all three primaries together and you get white light.

Pastel colours

Pastel shades are desaturated versions of full-strength colours and, being less forceful and strident, they tend to evoke a calm and refined mood when used in photographic compositions.

A touch of colour

In a largely monochrome scene such as this, a small area of intense colour can have a huge impact.

Intense colour

The intense colour of these enormous lengths of dyed yellow fabric looped over poles to dry conjures up the experience of the hot Indian sunshine. Note, too, how the yellow jumps forward, seeming to advance off the page as it demands your attention.

Seeing in black and white

Photographs in black and white are an abstraction – a step away from what your eyes see as reality. As a result, subject attributes such as tone, texture, shape, and form take on greater impact. Many people regard colour as the only medium, relegating black and white to some bygone era. In the brief history of photography, the first 70 years were all about black and white as it evolved into a high-quality recording medium.

Recording colour imagery became possible in 1904, however it took until the 1930s before colour film stock became widely available. Indeed, it was not until the late 1960s that colour movies became customary. Black and white was part of our visual culture before colour photography appeared. Its graphic immediacy and authenticity can somehow appear more real. Colour can seem more about surface qualities.

Some photographers claim that when they have a black and white film in the camera they see in black and white, as they start looking for subjects that have the qualities that work well in terms of tone, shape, contrast, and texture. With colour film in the camera they are looking for a different type of image.

Today you can take any film-based colour image, scan it into a computer, and (with the appropriate image-manipulation software) change it into black and white, just as if it were a digital original. Then you can work on the image's contrast and lightness to match your vision.

TIP

To see in advance what a colour scene might look like on black and white film, use a Kodak Wratten 90 viewing filter.

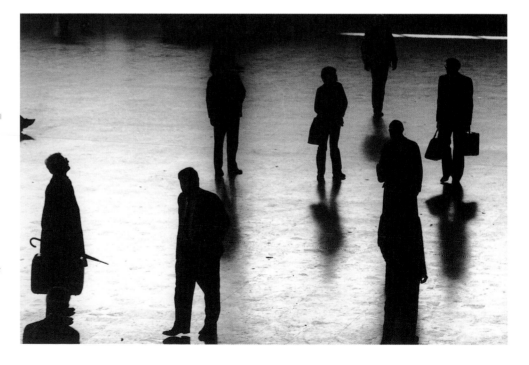

Graphic imagery
The appeal of the graphic simplicity of black and white is illustrated in this high-contrast scene. Note how the absence of half-tones has reduced the figures to two-dimensional shapes, while their shadows display the gradation of tones necessary to depict form (see p. 51).

Colour into black and white

The delicately coloured image above of a snow covered field in Scotland is a successful picture in all respects. Comparing it with the intriguing black and white version, which was taken a few years before, it's interesting to see how the absence of colour has abstracted the image, allowing the observer to read the perspective and geography in a variety of ways.

Visualizing tones

It is a great help to be able to visualize the way black and white film records colours – some distinctly different colours may appear to have near identical tones, while similar colours may appear as very different shades of grey. Some people may remember the classic television commentary on a snooker match, which was along the lines of: 'For those watching in black and white, the green ball is just behind the blue.'

As a first step, think about the contrast in the image and the balance of tonalities from dark to light. You could, through your choice of subject matter and exposure, produce a print containing only lighter tones or only darker ones – these are known as high- and low-key images (see p. 51). But you don't have to have a true black or a pure white in a print if it isn't in the subject. Exploring the limits of what the film and the camera can record is part of the interest of working in black and white.

The range of tones in a black and white image has been compared to a piano keyboard, with low-sounding notes at one end moving up to high-sounding notes at the other. People talk of the resonance created in black and white when a dark tone is set against a light one, or light against grey, or grey against black. The variables are many.

Think of a snow scene that is all white, except for a single tree standing out in silhouette – there is a resonance here that can create a powerful visual statement. Likewise, a long-exposure night photograph might have a single streetlight creating a ball of brightness against a black sky. A simple image, but powerful nevertheless.

Working with light

The more you understand about the qualities and science of the light illuminating your subject, the better your photographs are likely to be. The colour of light is very variable, and while your brain can adapt to different lighting conditions, seeing colours as you know them to be, film is balanced to give correct colours under specific lighting conditions.

Additive colour

Where two primary colours of light overlap, or add together, a secondary colour is formed; where all three primaries overlap, white light is the result.

The daylight we use in general photography is part of the 'visible spectrum' our eyes can register. The visible spectrum, with wavelengths between about 400 and 700 nanometres (nm), is just a small part of the electromagnetic spectrum, which incorporates x-rays, radio waves, infrared, and, below 400nm, ultraviolet (UV). Although you

can't see UV light, it will record on film, hence the need for a UV filter. The visible spectrum is most obviously characterized by the rainbow colours we are familiar with, made up of violet, blue, green, yellow, and red, which combine to make white light. If you split a beam of sunlight with a prism onto white paper, then you see all the colours

Colour temperature scale

Every light source has a colour temperature, measured in degrees Kelvin. The lower the colour temperature, the redder the light appears.

High colour temperature

Colour temperature has nothing to do with hot and cold as we normally perceive it. This frosty scene is strongly blue because it is reflecting a blue, cloudless winter's sky, which has a high colour temperature (about 8000K).

Low colour temperature

Lit by candlelight, this scene looks warm and cosy. However, in terms of colour temperature (about 2000K), it is much cooler than the frosty scene on the left.

Colour temperature

| Kelvin | 10,000 | 9000 | 8000 | 7000 | 6000 | 5000 | 4000 | 3000 | 2000 |

Blue sky (to 18,000K)

Hazy skylight

Overcast skylight

Fluorescent daylight tube

Average noon daylight

Electronic flash

Clear flashbulb

Moonlight

Photo floodlight

Spotlight

Projector lamp

60w lightbulb

Sunrise/sunset

Candlelight

separately. A simple experiment you can try is to project the three primary colours of light – red, green, and blue – as overlapping circles of light using torches and coloured gels. Where just two of the primaries overlap, a new colour, known as a secondary colour, is formed: red and blue make magenta; blue and green make cyan; and green and red make yellow. However, where all three primaries overlap in equal amounts, then white light is the result. This 'additive' theory of colour formation was first used in photography in the mid-nineteenth century by the pioneering Scottish physicist James Clerk Maxwell.

In order to prove his colour theory, Maxwell photographed a scene, recording the red, blue, and green components on three separate black and white film strips. He then projected the film strips using appropriately coloured light for each, ensuring that the images were precisely aligned. The result was a crude but full-colour image.

The colour of light

The colour of light around us is extremely variable, even if we are for the most part unaware of it. If, for example, you look at a piece of white cloth outdoors in bright sunshine and then take that same cloth indoors and look at it by the tungsten light of, say, an ordinary table lamp, the cloth will look just as white. This is because we see colours as we expect them to look. Film emulsion, however, is designed to react to light of a particular colour composition, of a particular 'colour temperature'.

To understand what is meant by colour temperature, which is measured in degrees kelvin (K), imagine that a black iron bar is being heated from cold. As the temperature starts to increase the first colour change the bar undergoes is that it begins to glow a red colour. As the heat increases, so the colour of the bar changes from red, moving through blue, before finally turning white.

Nearly all colour negative films are designed to give pretty accurate colour reproduction under both natural daylight (or electronic flash, which has the same colour temperature as noon daylight) and domestic indoor lighting, even though indoor lightbulbs give out a higher proportion of red wavelengths. This is because the colour response of the printing paper can be manipulated by coloured filters to correct for any obvious colour casts. Things go wrong when the printer (or automatic machine) does not know what colour your, say, shirt is supposed to be and so interprets the negative incorrectly. There is no printing stage with slide film, however, so this type of emulsion is either 'daylight balanced' or 'tungsten balanced', and you need to load the right type into the camera for the lighting conditions under which you are working.

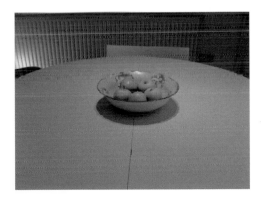

Domestic tungsten lighting
Exposing daylight-balanced slide film to ordinary room lighting produces this type of warm colour cast (above), because domestic tungsten is deficient in the blue wavelengths of the spectrum. Repeating the same shot, this time with a blue-coloured correction filter over the lens, gives an accurate colour result (right).

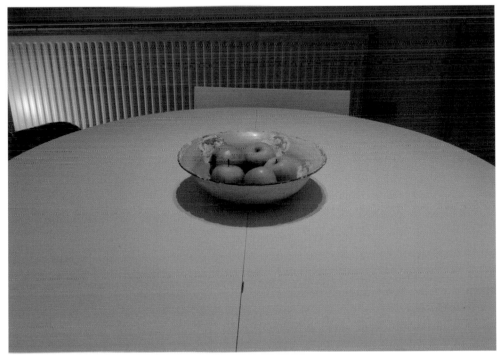

Near dawn

With the sun not far above the horizon, red wavelengths predominate, and so the colour temperature of dawn light is extremely low, at between about 2 and 3000K.

At midday

This picture was taken from the same position a few hours later on the same day, and you can see in this version how blue the Mediterranean sunshine can be at noon. The colour temperature here is about 9000K.

The variability of daylight

The colour of daylight varies not only throughout the day, but also (in temperate regions) from season to season. Beginners often think that bright sunshine is the best light to shoot in, forgetting that they will then have deep shadows and bright highlights to contend with. Many experienced photographers, however, prefer taking pictures in the soft, even lighting of an overcast day when contrast is lower. Low, early morning or evening sun can look dramatic in summer, casting long shadows, while in winter the sun doesn't climb very high in the sky, even at midday.

Daylight in different parts of the world varies according to your position in relation to the equator – the nearer to the equator you are, the shorter the twilight or early evening period will be; the further away you are from the equator, the longer the light lingers until, as in northern Europe, for example, the dark is banished altogether for a period during the summer season.

The highest colour temperature daylight reaches is that from a clear blue sky, at about 10,000K; the colour of an overcast sky is bluish and its colour temperature is around 7–8000K. If this light is too blue for your tastes then use an 81A warm-up filter over the lens when using daylight-balanced film.

Other light sources

Below about 5000K the colour of light becomes redder and will produce noticeable colour casts on daylight-balanced slide film. The types of light sources that work at this level include tungsten-halogen bulbs (at 3400K), photo floodlights (at 3200K), and candlelight (at about only 2000K). An 80B blue-coloured filter over the lens will restore the colour response of daylight-balanced film exposed under tungsten or photoflood lights (which are deficient in the blue wavelengths of the spectrum).

Fluorescent strip lighting is the most difficult artificial light source of all to deal with. It produces a green cast on daylight-balanced film and needs a magenta-coloured correction filter over the lens. There are, however, many different types of fluorescent light, and unless you have a colour temperature meter you will not know which type of magenta filter to use.

Digital white balance

Even though digital cameras don't use film, the colour temperature of the light sources is still an issue. Rather than using colour-correction filters (see pp. 32–3) as you would with a film-based camera, with digitals you can simply set the 'white balance' control instead. This control does what your eye/brain does instinctively, correcting the image for different colour temperatures so that you perceive colours as you know them to be. You can leave this on auto or make manual adjustments as follows:

A: On automatic, a sensor corrects the colour balance if it is within 3500–8000K.

Incandescent: This removes the yellow cast from tungsten-halogen lamps or photofloods at a colour temperature of 3000K.

Fluorescent: This counters the green cast from fluorescent lights at 4200K.

Direct sunlight: Ensures correct colour rendition at 5200K.

Flash: Produces correct colours under flash lighting at 5400K.

Cloudy: Removes the bluish cast present at 6000K.

Cloudy shade: Removes the stronger bluish cast that would exist at 8000K.

Working with flash

The advantage of working with electronic flash when natural light levels fall too low is that it has the same colour temperature as daylight (see also pp. 36–7). This means that electronic flash can be combined in the same pictures as daylight, to even out contrast by brightening subject shadow areas, for example, without causing any colour-cast problems.

Frontal flash, however, often produces a very harsh, unflattering lighting effect (see above). For a softer, kinder light, try bouncing light from the ceiling or a nearby side wall or, even better,

Direct, frontal flash
Built-in flash or accessory flash attached to the camera's hot-shoe will, typically, give this type of unpleasant lighting. Note, too, how hard the shadow is on the door.

Diffused flash
The harshness of the direct flash has been softened in this version, which was taken with a diffusing attachment over the flash tube. This technique is ideal for built-in flash.

Bounced flash
By far the best subject modelling is achieved by bouncing the light – here, by pointing the flash at the ceiling midway between the flash and the subject.

Unbalanced flash
With the camera lens set at f16, just enough flash light is recorded for the subject, but the rest of the room and the distant outside scene are hopelessly underexposed.

Balanced flash
Opening up the aperture 4 stops, to f4, the flash and daylight in the room combine to give a well-balanced exposure for both the main subject and room.

diffuse the light by placing a special white plastic attachment over the flash tube. Even a layer or two of a white handkerchief over the flash head will help to soften and diffuse its output. Take care if bouncing the light, however, for if the ceiling, walls, or any other intervening surface is coloured, the flash light will pick up this colour and cause an overall cast.

Processing
and printing

Developing black and white film

Developing your own black and white film allows you to exercise complete control over one of the critical stages of the photographic process. Once exposed in the camera, film contains a series of latent images. At this point, the emulsion on the film has reacted to light, but only at the atomic level; it is the film-development stage that amplifies this chemical reaction and makes the images visible. Film processing requires great care if you want good, consistent results, and once you have a good negative, a satisfactory print is far easier to achieve.

Colour processing and printing are not covered in this book, as most photographers use specialist laboratories for colour work. Colour negative film requires processing in C41 chemistry, while most colour slides need E6 chemistry. Some black and white films, such as Kodak CN and Ilford XP2, can also be developed in C41 as these films have dye-based emulsions. Again, a colour laboratory will develop this type of black and white film and produce a set of prints to your specification.

Home processing

Home processing film requires only a small darkroom area, but you must be able to make it completely lightproof. Even the smallest amount of light striking the film before it is safely loaded into the developing tank and with the lid in place will ruin your images.

Always be precise when handling film in the darkroom. You need sufficient chemical solutions to cover the film during processing. 35mm and medium-format film is held on a spiral inside a light-tight tank designed to minimize the volume of solutions required – 300cc for a 35mm film, 500cc for a 120 film – while large-format sheet film needs deep-tank or tray processing, like printing paper (see pp. 66–7). Mix the correct dilution (this varies depending on brand) of each chemical: developer (amplifies the latent image on the film, making it visible); stop (halts the action of the developer); and fixer (makes the image permanent by making the film insensitive to light). The temperature of the chemical solutions needs to be 20°C (68°F), if the processing times stated in the instruction sheet that comes with your chemicals are to hold. A warmer solution needs a shorter time; a cooler solution needs a longer time (see chart p. 65).

Developer

The choice of developer determines to a great degree the appearance of your final negatives. A high-acutance developer, for example, gives a sharp-grain negative, while a low-acutance developer gives soft-grain results.

Most developers are normal or high acutance, but Agfa Rodinal is very high acutance and can make 35mm film look too grainy. It works better with 120 or large-format film where the grain will be less noticeable. Grain is less noticeable with these films because the large size of the film original (in relation to 35mm) means that they require less enlargement to produce a good-sized print.

Film-processing equipment

The chemicals for black and white film processing need to be accurately measured using graduated cylinders or a measuring jug, and a thermometer ensures they are at the right working temperature. It is sensible to wear gloves when handling all chemical concentrates and solutions. Use scissors to cut the film leader square before removing the cassette cap and extracting the film, and a clock with an audible interval timer is essential for the processing stages. When the film comes out of the developing tank after processing and washing, squeegee off excess water and use film clips to help the film dry flat. Use a funnel when pouring reusable chemical solutions into their storage bottles.

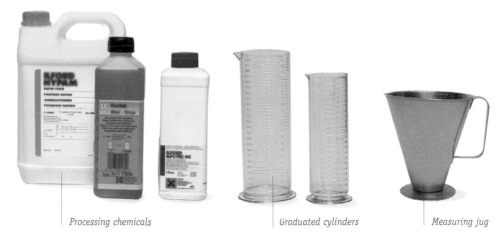

Processing chemicals

Graduated cylinders

Measuring jug

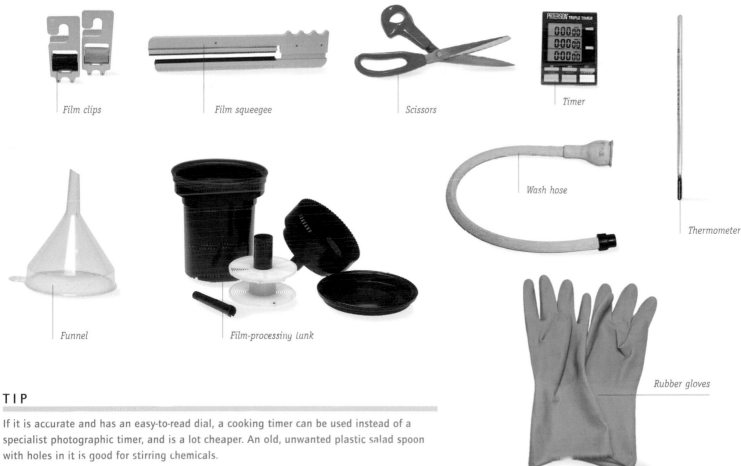

Film clips

Film squeegee

Scissors

Timer

Wash hose

Thermometer

Funnel

Film-processing tank

Rubber gloves

TIP

If it is accurate and has an easy-to-read dial, a cooking timer can be used instead of a specialist photographic timer, and is a lot cheaper. An old, unwanted plastic salad spoon with holes in it is good for stirring chemicals.

Loading a film tank

Take a pair of scissors and cut the shaped film leader of the 35mm film square. Take care to cut between the sprocket holes to ensure the film is less likely to jam later on. All further stages are carried out in complete darkness, so make sure you know exactly where everything you need is located.

In complete darkness, use a bottle opener to flip the top off the 35mm film cassette. Drop the roll of film carefully into your hand. (With medium-format rollfilm you must separate the backing paper from the film right to the end and cut it off.) Avoid touching the delicate emulsion surface by handling the film by its edges.

Start to load the film on to the spiral. The plastic universal spiral can be adjusted to fit 35mm or 120 rollfilm. The film must go in at the entry point of the two big notches, so keep these together to start with.

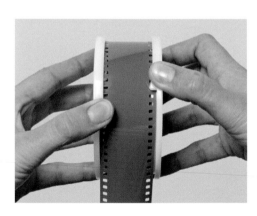

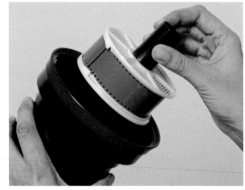

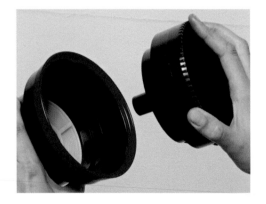

With the beginning of the film safely loaded in at the spiral entry point, start to twist the sides of the spiral alternately backwards and forwards to draw in the rest of the film. Hold your thumbs over the notches as you twist to prevent the film jumping out. Make sure the film does not kink and it all sits neatly within the spiral. Don't cut the film from the central core until the last moment, as its weight will stop the film from tangling.

Place the loaded spiral on to the column and then into the tank. If developing one film in a double tank, put an empty spiral on top of the loaded one. Fit the top of the tank and twist it to lock. You can now turn the light on

and prepare the processing chemicals. Use accurate measuring cylinders and always use the same one for each of the developer, stop, and fix solutions to prevent contamination.

TIP

It is useful to leave the film leader sticking out when you rewind the film in the camera, so you can cut it off between the sprocket holes in the light. This is often not possible with cameras that rewind automatically. A film retriever can extract it from the cassette if it is wound in too far.

Develop the film for the time stated on the information sheet accompanying the product. If you extend the development time you will increase the contrast in the film, which may benefit low-light pictures. Alternatively, reducing development time will lower the contrast of the negatives, which is good for contrasty subjects. Such changes should be done in 10–20% gradations of the overall time, as a rough guide. If you increase dilution of the developer you need to extend development time, which will produce negatives with more shadow detail and good highlights. Reduce development time if you reduce the dilution.

The processing sequence

• Pour the developer solution into the tank and start the clock. Put the lid on the tank and agitate it for the first 30 sec. Tap the tank firmly on the edge of the bench to dislodge any air bubbles that may have attached to the film surface. Then agitate for 5 sec in every 30 sec thereafter until the end of the development period. Then pour out the solution. If you over-agitate you increase film development, and increase the contrast of the negatives.

• Pour in the stop bath, which is acidic and neutralizes the alkaline developer and halts its action. Stop bath also prolongs the life of the fixer. Agitate the tank for 30 sec, leave it to stand for 30 sec more, then pour out the solution into a bottle using a funnel, as it can be reused several times. Wear protective gloves so that chemicals don't splash your skin.

• Pour in the fixer, reset the clock, and agitate the tank for the first 30 sec, and then for 5 sec in every 60 sec. The film changes from white to a clear negative during fixing, as the unused silver emulsion is dissolved, leaving the cleared, developed image behind. Leave the film in the fixer for double this clearing time, which is

Time and temperature chart

18°C/64°F	19°C/66°F	20°C/68°F	21°C/70°F	22°C/72°F
5:00	4:30	4:00	3:30	3:15
5:30	5:00	4:30	4:00	3:45
6:00	5:30	5:00	4:30	4:00
6:30	6:00	5:30	5:00	4:30
7:15	6:30	6:00	5:30	5:00
8:00	7:15	6:30	6:00	5:15
8:45	7:45	7:00	6:30	5:45
9:15	8:15	7:30	6:45	6:00
9:45	8:45	8:00	7:15	6:30
10:30	9:30	8:30	7:45	7:00
11.15	10:00	9:00	8:00	7:15
11.45	10:30	9:30	8:30	7:45
12.30	11:15	10:00	9:00	8:00

usually 5 min in total – longer with T-MAX films or if the fixer is older. After much use, the fixer has to be discarded, as it has too much silver in it. Silver Estimating Papers change colour when dipped into the fixer, according to how much dissolved silver it contains.

• The washing stage is crucial as it removes the fixer that will damage the negatives over time. Feed a washing hose into the core of the spiral and run cold water into the tank for 20 min. Hypo clearing agent can be used to speed up the wash sequence.

• After washing, open the tank, cover the film with water, and add a few drops of wetting agent. Agitate by lifting the spiral up and down for a minute. Wetting agent prevents drying marks on the negative and stops the negatives curling up, which is important when printing

• Take the film off the spiral carefully and use a film squeegee to remove excess water. Make sure the squeegee blades are clean as any grit will scratch the film. Then hang the film up to dry in a dust-free room or cabinet. Use film clips at the top and bottom to weigh the film down and help it to dry flat. You can use clothes pegs, but specialist film clips are better. Drying takes 10 min in a drying cabinet, or air-dry the film somewhere dust-free for about 2 hours.

• Once dry, hold the negatives by their edges and cut the film into strips to fit your negative bags. A 35mm negative bag has 7 sections, so cut the film into the appropriate number of strips, depending on how many exposures are on the roll. Don't cut negatives into 3s or less as they are hard to handle when printing. Use clear negative bags so you can make a contact sheet without removing them (see pp. 68–9).

Printing basics

'Magic' is often the word used by people seeing one of their images start to emerge in the developing tray for the very first time. A good print is, more often than not, the result of working with a good negative. If your original is optimum – correctly exposed in the camera and then correctly processed and developed – then it's a relatively straightforward matter to produce a good print. A skilful printer can retrieve a bad negative, making adjustments to overcome the original's shortcomings, while a good negative can make even the novice printer look like an expert.

The more printing you do, the better the photographer you will inevitably become, as it is through your time in the darkroom that you begin to understand what is needed to achieve a good print. Given time, you will start to visualize how the final print will look when you see the subject in the camera's viewfinder, for in your mind you will be taking into account the characteristics of the camera, the lenses, and your choice of film, as well as all the processing and printing variables.

Just to reiterate that colour printing is not within the scope of this book, and most people rely on specialist laboratories for colour film processing and printing.

The negative/positive process

When light from the subject strikes the film in the camera tiny changes take place in the light-sensitive silver-halide crystals that make up the emulsion. During film development, the light-affected crystals (corresponding to the bright parts of the subject) are turned black or grey, depending on how much light they were exposed to, while the areas of emulsion that received no

light (corresponding to the subject's shadows) are removed to leave clear film. So, in this way, bright parts of the scene are translated into dark areas of film, while dark areas of the scene are translated into clear areas of film.

When you make a print, light floods through the clear areas of the negative to the paper beneath (causing the paper to turn grey or black after processing), but is blocked from reaching the paper by the dark areas of the negative (causing the paper to remain light or white after processing). Thus, a negative film original produces a positive paper print.

The processing sequence

The processing sequence for prints is similar to that for film (see pp. 62–5). The three principal chemicals are, again, developer, stop bath, and fixer (in open trays, however, rather than in a closed tank), followed by a wash sequence and print drying. Although these chemicals have the same names, you cannot use film-processing chemicals for making prints, and vice versa. The times for each stage vary depending on the type of paper you are using.

There are two main types of printing paper: resin-coated and fibre-based. The former is a plastic-coated paper designed for quick processing. Because of the plastic coating, the chemicals cannot penetrate into the paper's base and so typical processing times are: 2 min development, 30 sec stop bath, 3 min fixer, and 5 min wash. Print-drying times are also massively reduced and prints dry flat, without curling at the edges. Resin-coated paper can also be processed through a machine that completes the whole sequence in 60 sec, partly due to the special chemistry and higher temperatures that are used compared with the normal open-tray method (see pp. 68–9). Most people learn to print on resin-coated paper, moving on to fibre-based paper when they are more confident.

Fibre-based paper has no plastic coating and so the base absorbs the chemical solutions. As a result, typical processing times are: 2–4 min development, 30 sec stop bath, two fixer baths of 4 min each, 30 min washing, and 3 min hypo clearing agent to remove the fixer residue from the paper. Fibre-based prints are best dried back to back on a line, pegged in the corners, and then flattened (often under heavy books) when dry.

The essential darkroom

Many people's first experience of printing will be in a purpose-built darkroom in a school, college, or hire facility. The room should be laid out in accordance with all local health and safety regulations and, as a priority, it must have an efficient ventilation system to clear away the fumes from the processing chemicals. Although they are not generally dangerous, some individuals may be particularly sensitive to the fumes, especially if confined in a very small area.

Setting up a darkroom at home is not difficult, but it's best if you can dedicate a separate room to it, with its own plumbed-in water supply, power supply, and air extractor. If you improvise a part-time darkroom from, say, the kitchen, then make sure no food items can be contaminated by coming into contact with processing chemicals.

Needless to say, any darkroom must be made completely lightproof, so an interior room with no windows will be the easiest space to convert. Otherwise, use blackout blinds at the windows and seal the cracks around doors.

In terms of layout, darkrooms are best divided into the dry side and the wet side. On the wet side of the room, carry out all film and print processes involving water and liquid chemicals. In addition, store all film tanks, measuring cylinders, print trays and other equipment that comes into contact with liquids on this side of the room.

On the dry side, keep your processed and dried negatives, boxes of printing paper, printing frames, and of course the enlarger.

Basic darkroom layout

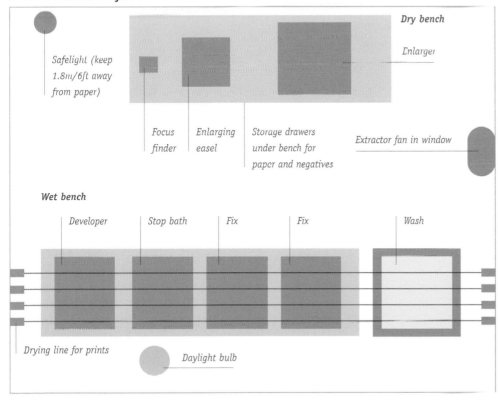

Safelight (keep 1.8m/6ft away from paper)

Dry bench

Enlarger

Focus finder | *Enlarging easel* | *Storage drawers under bench for paper and negatives*

Extractor fan in window

Wet bench

Developer | *Stop bath* | *Fix* | *Fix* | *Wash*

Drying line for prints

Daylight bulb

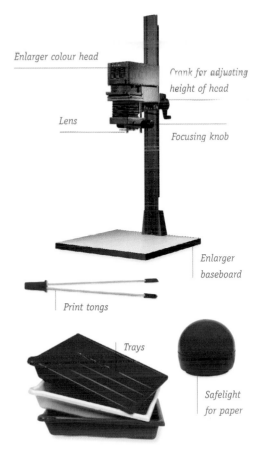

Enlarger colour head

Crank for adjusting height of head

Lens

Focusing knob

Enlarger baseboard

Print tongs

Trays

Safelight for paper

Making a contact sheet

A contact sheet is a convenient way of viewing a film's worth of negative-sized pictures on the same piece of printing paper. By printing the negatives in contact with the paper, you can view a series of small, positive images of all your work, choosing which pictures to enlarge as full-size prints, which to crop, which have technical problems to deal with, and which have simply failed and are not worth taking any further.

TIP

Always clean the glass or plastic lid of your contact printing frame before using it.

Producing a test strip

Place the empty contact printing frame (see below) on the baseboard of the enlarger (see p. 67), and turn on the light when the negative carrier is in place. Project the light on to the baseboard and raise the enlarger's head on its column until the light beam covers the whole contact printing frame. Adjust the focus so that the edges of the negative carrier silhouette appear sharp – if they are unsharp the light might not cover the paper evenly. Stop the enlarger lens down to f5.6 and turn off the enlarger. Next, in normal room lighting, load the lid of the contact printer with your strips of negatives, emulsion-side down.

Turn the room light off and, working under appropriately coloured safelighting, cut a test strip size of paper – about a third of a sheet – and place it on the foam-rubber base, emulsion-side up, so that it corresponds to a representative sample of the negatives. Close the lid of the frame and clamp it firmly in place.

Turn the enlarger light on and make an overall exposure with the timer set for 5 sec. Keeping the enlarger on, cover a quarter of the printing paper with a piece of black card, held at a right angle to the negative strips, and give the rest of the paper another 5-sec exposure. Make another two 5-sec exposures in the same way, covering the printing paper progressively each time.

The contact printing frame

A contact printer has a hinged glass lid, designed to hold strips of negatives on its undersurface, and a baseboard with foam rubber to support the printing paper. Negatives must be placed in the lid emulsion-side down, while the paper is placed on the baseboard, emulsion-side up. In this way, when the lid is closed and clamped shut, the negatives and paper are firmly in contact emulsion-to-emulsion. You can make your own frame using a large piece of heavy glass and a piece of board covered in foam rubber. Lay strips of negatives on top of the paper on the board and place the glass on top to keep the negatives and paper in contact.

To process the test strip (see also p. 66), slip it into the developer solution face down and start the timer. Use print tongs to turn the print over and ensure it is completely covered with solution. Gently agitate the tray. At the end of development, use the tongs to transfer the test strip face down into the stop bath (don't allow the developer tongs to enter the stop solution or they will contaminate it). Start the timer and use fresh tongs to agitate the test strip. Use the tongs to transfer the strip face down into the fix. Start the timer and agitate it for the first 20 sec.

After about 1 min in the fix, turn the strip over. You can now inspect the test strip under room lighting or, better, a white daylight bulb – it should show a series of four exposures becoming progressively darker. A good test strip has one step too light, one too dark and a choice in the middle of two that are close to the correct exposure time.

Use the test strip to choose the correct exposure time for the whole contact sheet. It is unlikely that all pictures will be correctly exposed on a contact sheet – a standard exposure will not suit the needs of 36 individual images and some will be too dark and some too light. But you should have more than enough information to decide which ones you want to make into full-sized, individual prints.

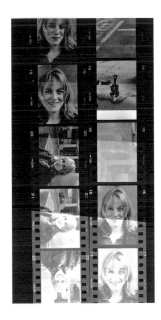

The test strip

The processed test strip displays a series of exposure bands. The lightest part of the strip was exposed for just 5 sec, the next for 10 sec, the next for 15 sec, and the darkest segment for 20 sec.

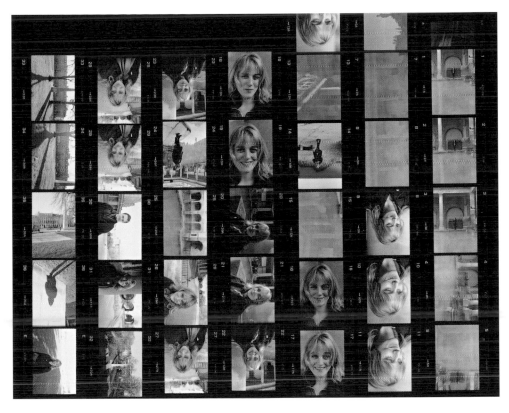

The contact sheet

Using the exposure information provided by the test strip, choose the best exposure and make a contact sheet using a full sheet of printing paper. No single exposure can suit the requirements of so many different negatives, but you should have a good guide to deciding which ones to take further.

Paper grades

When making a contact sheet, or indeed any sort of black and white print, you have to decide what contrast grade of paper to use. Printing paper used to be available only in packets or boxes of single-grade papers, such as 00, 0, 1, 2, 3, 4, or 5. The lower the number, the softer the contrast. Grade 5 could, for example, be so contrasty that only blacks and whites would reproduce, with no shades of grey at all. A normal-contrast negative would print well on grade 3; a 'thin', or underexposed, negative would print best on grade 4 or 5; and a 'denser', or overexposed, negative would print best on grade 1 or 2. Sometimes you can print a normal negative on grade 5 simply because you like high-contrast results. These graded papers are still available, but are being eclipsed in popularity by multigrade, or variable-contrast, printing papers.

The big advantage of multigrade is that you buy just a single box of paper and, by changing special filters in the enlarger head, you can achieve the complete range of print contrasts from 00 to 5, with half grades as well.

The enlarger light is biased towards blue, so when you place a multigrade filter in the enlarger head it changes the colour of the light projected through the negative, and the paper responds to this change by altering the contrast of the print. A yellow/orange filter will give a soft print at 00, 0, and a magenta filter gives the maximum contrast of 4, 5. The middle filters change the colour of the light from the enlarger towards red.

When using contrast-changing filters, exposure times are the same from 00 to 3½, but you have to double the exposure time when using filters 4, 4½, and 5. Thus a 10-sec exposure through filter 2 would turn into a 20-sec exposure through filter 4, 4½, or 5 from the same negative.

A good idea is to make a contact sheet slightly softer, or lower in contrast, than you would a normal print. This will give you more information about the shadow and highlight detail. Always remember that a contact sheet is a reference, not the end result.

Making a print

The print is the culmination of the whole process of photography, and a good print is the end result of getting all the earlier stages right. It is a negative-positive process and the print is largely determined by the detail present in the negative. You can learn to read the negative on a light box, or by holding it up to a bright, even light. The contact sheet also provides a lot of useful information about how negatives are likely to print.

When examining a negative, look to see if there is good shadow detail you can bring out in the printing. See how dense the highlights are - if they are very black, you may not get much highlight detail in the print. It can be good to have a solid black or a solid white area in a print, so don't become obsessed with trying to achieve subject detail throughout the print.

With the contact sheet as your guide, choose the pictures you want to print, looking for things such as composition, lighting, and subject matter. The contrast filter you chose for the contact sheet gives a good indication of the contrast grade the final print will require, but there is no relationship at all between the exposure time of the contact sheet and that of the enlargement.

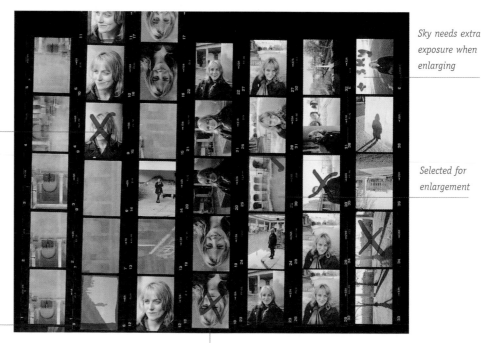

Sky needs extra exposure when enlarging

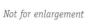
Not for enlargement

Selected for enlargement

Crop as marked when enlarging

Not for enlargement

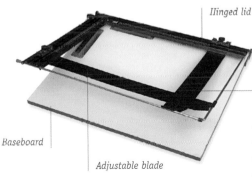

Hinged lid

Adjustable blade

Baseboard

Adjustable blade

Enlarging easel

*Easels usually have two fixed sides and two
blades making up the other sides that you can
slide along to create any rectangular shape.
To make a white border on a print, you have
to crop into the image area all the way
around. A border is made by adjusting an
inner setting behind the two fixed sides. Slide
the paper under the top part of the easel up
to these two marks so that when you close the
easel it masks the paper. The two blades can
be set to the proportions of the negative
format, as you project it on to the easel.*

Eyepiece

Light from enlarger
enters here

Internal angled
mirror

Stand is placed on
projected image

Eyepiece cap

Focus finder

*As you look through the finder's eyepiece you
see a greatly enlarged area of the projected
image. Part of the light from the enlarger
is diverted into the finder via an angled
mirror. As you adjust the fine focus control
you will see the grain of the image literally
snap into focus.*

Getting started

Take the strip of negatives carefully out of its
sleeve, holding it by the edges only. Never put
fingerprints on the picture area as the natural
grease on your skin is very difficult to clean off.
If the negatives are dirty, dislodge any loose dust
first and then clean them with cotton wool
dipped in methylated spirits, or use a proprietary
brand of negative cleaner.

Line up the negative you want to print in the
negative carrier of the enlarger, emulsion-side
(dull-side) downwards, and with the image upside
down. The enlarger lens projects an inverted
image so you will see the image the right way
around. Turn the room light off and the enlarger
light on. Using the height-adjustment knob, move
the enlarger head up or down to change the size
of the projected image on the enlarging easel
(see left) on the baseboard. Then set the easel's
blades to the correct size.

Lens and exposure

With the easel, size of enlargement, and borders
set, focus the image using a focus finder (see left)
with the lens wide open. This gives you the
brightest possible projected image and allows you
to focus on the grain of the negative. Place the
finder in the middle of the picture area.

Now stop down the lens by 2 stops, or clicks,
on the aperture ring. As with a camera lens,
making the enlarger lens aperture smaller
increases the depth of field (see pp. 16–19) and
so increases the sharpness of the projected image.

If you focus correctly, any print should have a
sharply rendered central area; stopping down the
lens helps to bring the corners and edges of the
print into sharper focus.

Making a test strip

After focusing the negative on the easel, decide which contrast filter to use for making your test strip (see p. 69). For a normal-contrast print from a normal-contrast negative, start with a filter from the middle of the multigrade range, such as 2, 2½, or 3. If you want maximum contrast, then go for filter 5. But whatever effect you want to create, do put in a filter to start with as it will affect exposure times.

Contrast in printing is a very subjective issue – some people like more, others less. If you produce a contrasty print you lose shadow and highlight detail, but you gain more texture. If you print normally, or a little on the soft side, then you increase shadow and highlight detail, but you sacrifice some of the texture.

As a starting point, choose the same contrast filter used for the contact sheet and then set the timer for 5-sec intervals. Turn off the enlarger and the room lighting and, with safelighting on, cut a test strip and place it emulsion-side up where the picture will give you the most information – for example, over the highlights and shadows. Expose the test strip in 5-sec exposure bands, as you did when producing a contact sheet (see p. 68).

Process the test strip (see p. 66) and examine the results under room light or a daylight bulb, choosing the exposure step that has the best shadow and highlight detail. If the test strip is all too dark, then stop down the lens further by 1 or 2 stops, and make another test strip. If it is all too light, then make another strip using the same lens aperture but add a further 5-sec exposure step.

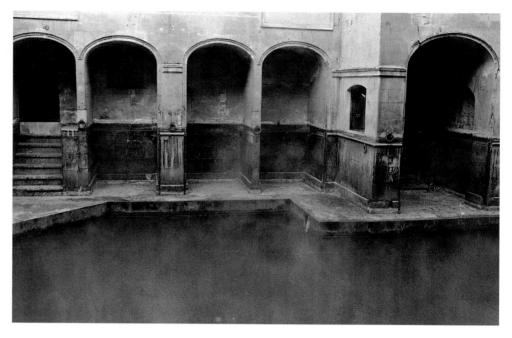

Enlargement
The final enlargement was exposed through a number 3 contrast filter.

Test strip
Position the strip of printing paper where it will reveal most information about the negative's highlights and shadows.

TIP

When making a test strip for a print, try not to touch the paper with the card, as it can move the paper, causing a blurred image.

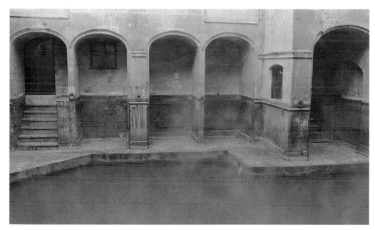

filter 0

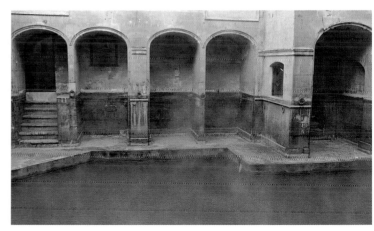

filter 2

filter 4

filter 5

The final print: dodging and burning-in

Using the exposure information from the test strip as a guide, make your first full-sized print. After processing, blot off excess water, and look at it under room lighting. The likelihood is that it will need some fine tuning and so you may need to change the exposure to make the next print a little lighter or darker. Or you may want to change the filter to alter contrast.

Rather than making changes to the entire print, you may want to exercise local control – perhaps just part of the image needs more or less exposure. Often, shadow areas benefit from being 'dodged' in the main exposure to lighten them a little, while sky areas, or other bright highlights, may need 'burning-in', or darkening, by locally extending the main exposure (see pp. 134–7).

A dodging tool is a thin, flexible wire with a piece of masking tape on the end, which you can introduce into the enlarger's light beam to shade

areas of the paper during the main exposure. 'Burning-in' is best done by using a piece of card with holes cut into it corresponding to the areas of the print needing extra exposure. Held over the paper, the card shades the rest of the print and prevents it receiving too much light.

When dodging or burning-in keep the tools on the move. Otherwise you will see a distinct change in tone matching the shape of the wire or apertures in the card. Record any changes in case you want to repeat results at a later date.

Print finishing

Photographic prints can be enlarged as full-frame images with black borders or cropped, scale can be distorted through paper size, or the image can be reversed. All negatives, no matter what their format, can be cropped to form panoramas, squares, circles, or ovals. Retouching, or spotting, a print can make a huge difference to its appearance, changing features or removing blemishes to flatter the subject, or restoring the damage on a treasured old image whose negative has been lost.

TIP

To see the potential of cropping, make two L-shaped pieces of card that can be overlaid on a print and adjusted to suit.

Full frame with black border

There is a tradition of printing 'full frame' with a black border, using a negative carrier whose frame edges have been filed back. With the aperture enlarged, you can include the edges of the negative, which will appear black in the print. This is a favourite technique of 35mm reportage or documentary photographers (see pp. 116–19), as printing the whole negative provides an added sense of 'realism'.

To prevent light from the enlarger bleeding through the film sprocket holes, causing dark blotches on the print, use light-tight photographic tape to mask them off and adjust the easel blades to tidy up the black edge for a sharp finish.

Filing back a negative carrier is not easy. Even with a fine file results are likely to be uneven, and tiny bits of metal will stick out to scratch your negatives. It is better to send the carrier to a metalworking company to remove 1mm all around. Then paint it black with anodized paint.

Inversion and scale

To produce a correctly orientated print, print the negative emulsion-side down. If, however, you print it emulsion-side up you will produce a mirror image of the original. This could result in an abstract image and even improve some compositions.

The scale of the print is a key influence on how the image is viewed. Print size is limited to the size of sink, trays, and washing system you have in your darkroom. Some people print to the maximum size before the film grain becomes too prominent – about 30 x 40cm (12 x 16in) with 35mm or 50 x 40cm (20 x 16in) with 120 rollfilm – while large-format negatives can go much larger. Small-scale prints often have a fine, virtually grain-free look.

Scale also has to do with subject matter. A landscape may work better bigger, with fine grain, much detail, and a wide view. A still-life or close-up may work better as a small, almost intimate print, for the subject is small in real life. However, rules are meant to be broken.

Full-frame image
The black border around this print indicates that it was made from the entire negative. This tells the viewer that the photographer thought carefully about framing and composition at the time of shooting.

Panoramas
Any format can be cropped to create a panoramic-type image.

Cropping

Using the blades of the enlarging easel you can easily create a panorama or square-shaped print, no matter what the original film format. Indeed, it can be liberating to print different shapes, breaking away from the proportions of printing the whole negative format. Cropping can also be used to adjust a print by, say, correcting a sloping horizon or vertical, or removing a distracting detail at the edge of the frame that is weakening the overall composition.

A circular or oval border, or vignette, can be created by cutting the appropriate shape in a piece of card and holding it above the print during the exposure. Move it up and down a little, to create a soft, blurred edge. If you lay the card in contact with the paper, you will get a very sharp-edged border.

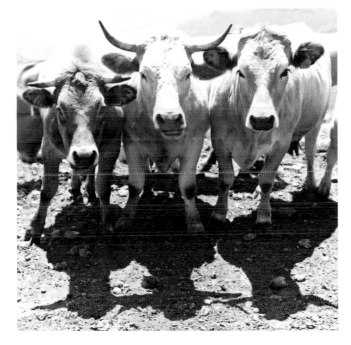

Cropping to a square
The original film format here is 6 x 7cm, but as you can see it can be easily cropped to give a square format. This type of treatment can be used to remove distracting detail at the edges of the frame or simply to concentrate attention on a particular part of the scene.

Print repairs
The easiest type of print to repair is one on textured or matt-finished paper (see below left), as the minute irregularities in the paper's surface scatter light and help to disguise the presence of the ink. Allow a little time between adding ink layers as ink tends to lighten a little as it dries.

Retouching

Water-based inks are best for retouching, using a very fine watercolour brush. Put some of the ink on a white saucer and dilute it with a little water, testing the strength of the ink on a sheet of white paper, laid over the print, to match the tone you need to retouch. Build up the ink gradually, so it doesn't become too dark – start light and add more and more in small increments.

Warm tone, cold tone

An important choice when making a print is the combination of paper and developer you use. Whether you are fine printing (see pp. 134–7) with fibre-based paper or producing a quick print on resin-coated, there are variations of image colour to consider.

You may think that black and white means exactly that, but there are in fact some printing papers that tend towards a blue-black, or cold-tone, effect and those that are slightly brownish in colouration, or warm tone. In the middle of this range are the neutral papers, which are not biased either way. The warm-tone papers often have a cream-white base, while the cold-tone types have a very clear white base.

Print developers also vary in their colouration, ranging from cold, through neutral, to warm tone. They also vary a little in their contrast, with the

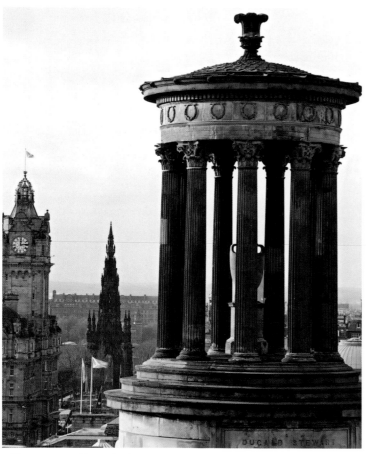

Cold-tone paper, cold-tone developer

Cold-tone paper, warm-tone developer

soft-working developers giving a grade softer than a normal-contrast developer. A warm-tone fibre-based paper responds well to changes in the type of developer used, but cold-tone papers tend to respond less well.

You might have a different emotional response to a warm-tone print, rather than a cold-tone one. A warm-tone paper might suit a landscape, still-life, nude, or portrait, but a cold-tone paper may be better for documentary work or reportage. Test different papers and developers to find what suits your needs and personal preferences.

Combinations

A warm-tone paper that is processed in a warm-tone developer may take on a slightly sepia or brownish colouration. My favourite combination is a warm-tone, fibre-based paper processed in a cold-tone developer, which gives a slightly extended tonality.

A cold-tone paper in a cold-tone developer will look very cold, or blue-black. A cold-tone paper in a warm-tone developer may not look very different from a neutral developer.

TIP

The surfaces of papers also vary, from standard glossy, to textured types such as pearl, satin, or matt. These categories vary between brands, and a glossy paper in one brand might be more matt in another.

Warm-tone paper, cold-tone developer

Warm-tone paper, warm-tone developer

Toning a print

Toning affects the black and white print by changing its colour. Toning also helps to archivally preserve the image. First, you must fully process the print (see pp. 66–73), taking care to fix and thoroughly wash it – any fixer residue remaining in the paper base may cause surface stains as a reaction to the toner chemicals. Toning is a daylight process, one that is best carried out by an open window, or somewhere well ventilated, as the toners used give off fumes that are best not breathed in. Wear rubber gloves to prevent any of the chemicals splashing on your skin, and use print tongs (plastic or bamboo), to agitate the prints and turn them over. You can tone a dry print, if you soak it in water first to soften the emulsion.

TIP

Keep separate trays for toning. Any trace of processing chemical left on your ordinary trays may contaminate the toner and stop it working properly.

Archival toning

You can tone prints that have been made on both resin-coated and fibre-based paper, but the latter is better for archival, or fine printing (see pp. 134–7). Toners such as selenium or gold are largely wasted on resin-coated paper because this material is not really designed for permanence. As well as increasing longevity, the archival toners also enhance prints visually in subtle ways, by introducing small colour changes and also by increasing the density and tonal range of images, giving them a blacker black.

Selenium is poisonous, so use it with great care. If you tone a print in a strong mix, such as 1:3 with water, the print will turn red; however, it is more usual to use a weaker dilution, such as 1:20 or even 1:40 with water to introduce subtle tones. The archival element of the process comes about because the toner bonds with the silver gelatine emulsion, protecting it from degrading over time and increasing the densities.

Some people tone negatives with selenium to intensify them if they appear to lack contrast.

Original print

A 'split tone' is when you tone just enough for some tones to change colour, while others stay the same. To create a split, use selenium toner at a dilution of 1:12 and leave the print in the toner until the blacks and mid-tones turn a reddish hue, but the other areas remain unaffected. This treatment can be worthwhile with, say, a still-life subject, but I don't like it with portrait subjects or with landscapes.

Gold toner can also be used for archival permanence, but it is expensive and, strangely, doesn't change the colour of the print to gold; instead it goes bluish, or slightly cold in tone. It will enhance the blacks as it bonds with the emulsion and protects it, in the same way as selenium toner.

Coloured toners

These change the colour of the print strongly, and come either in powder form you dissolve in water, or as liquids you dilute with water to make a working-strength solution. Temperature is important as the toner works more quickly the higher the temperature. Work at 20°C (68°F) and you should get optimum results.

Most colour toners, including blue, copper, green, yellow, and red, are one-bath processes: you put the print in, agitate it gently for about 5 min, and the print changes to the colour of the toner in use. Take the print out, wash for 15 min, and hang it up to dry. Blue toner is tricky as the whites go yellow; wash the print in a bath of weak salt water to remove the yellow discoloration, but remove it before the blue disappears.

Before sepia toning a print it must first be bleached in a solution of potassium ferricyanide and potassium bromide. Once the image has disappeared, rinse the paper in water – when you place it in the toner the image will reappear in tones of sepia. Both steps take about 3 min. You can usually colour about ten prints in one bath of toner before the chemistry stops working.

Copper toning

Sepia toning

Blue toning

Green toning

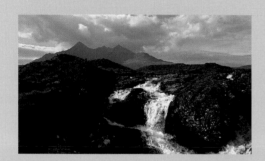

Specialist subjects

Portraits: Face shots

It is important to pose the question, what is a portrait? The obvious answer is that it is an image dominated by the likeness of a person or of people. But a portrait is surely more than this. If you fill the frame with a face you will record the sitter's characteristics, but not necessarily anything of the person's character. A portrait should reveal something of personality, and in order to achieve this objective the photographer has to connect with the subject.

Unless sitters are used to being in front of the camera, most are initially nervous. To relax them, engage them in conversation while you walk around, looking for the best angles to shoot from. And keep talking to and engaging with them throughout the session.

No face is symmetrical, so look for the best side. Be prepared to write off the first few frames until the sitter has become used to the camera and, if flash is being used, the sudden bursts of light followed by the whining as the flash recharges.

The most crucial part of the face is the eyes, so always ensure they are sharply focused. In low light with a wide aperture and shallow depth of field, it will look like a mistake if the subject's nose or ear is sharp, but the eyes not.

Lens choice

The type of lens suitable for portraiture is one that does not cause any obvious facial distortion. You could fill the frame with a face using a 24mm lens (on a 35mm camera) by moving in very close, but the effect would be almost comical, with the nose and forehead looming large in the frame while the ears retreat into the far distance. Move way back, and you can fill the frame with a 400mm telephoto, but then the subject's face would look squashed, almost as if it

were all largely on a single plane. The lens that is generally accepted as being ideal for the face shot is one within the range 70–105mm (on a 35mm camera). This short telephoto range will bring you visually close to the face without intruding too much on the sitter's personal space and, more importantly, it produces no distortion

Lighting approaches
Try using window light for a face shot – position the subject correctly and you could have a pleasant sidelight producing characterful shadow and highlight areas. Placing a reflector on the side opposite the light will open up the shadows, and a reflector below the face helps to lighten skin tones, taking away shadows under the eyes and making the face look younger. If you need to supplement the daylight, avoid direct on-camera flash, which will give harsh, contrasty results. Diffused flash will yield softer, more sympathetic results when combined with daylight (see p. 59).

of the features. Indeed, the 90mm lens is referred to as a 'portrait lens'.

Don't be afraid to shoot lots of film – think of it as being a sketchbook to try out ideas, and expect to print only around 10% of what you shoot. The contact sheet is perfect for editing material and picking out the best shots (see pp. 68–71).

TIP

TTL light meters average any subject to a mid-grey, which is too dark for a light-skinned person, so open up 1 stop. A dark-skinned person may be fine with the standard TTL reading, or may need 1 stop less exposure.

Soft and flattering

A soft-focus filter is the ultimate device for a flattering face shot, if you like the effect it creates. It can minimize skin blemishes and lines on the face.

Lighting contrast

Higher levels of contrast are considered more acceptable for the mature male's face as they emphasize character.

Portraits: People and environment

This type of portrait is quite different from the traditional face shot illustrated on the previous pages. Not only is the person smaller in the frame, the background is also crucially important to the way the viewer reads the picture. Here, the environments in which we see the subjects say something about them – where they live or work – or they make a statement about the type of people they are. The skill is in the composition – placing the person in relation to the surroundings, so that the picture works on all levels.

Choice of location is important, and many good portraits have been taken against very simple backgrounds with strong graphic shapes, lines, or textures. A teenager in front of a graffiti-covered wall has 'attitude', whereas a politician in front of an official building looks important, a powerful person. Swapping the locations and retaking the shots could be fun, and would certainly change the meaning of each image.

An artist shown in a studio is a possible theme for this aspect of portraiture, as is a writer hunched over a typewriter in a book-lined room. A musician in a rehearsal room with instrument and score, or a dancer in front of practice mirrors, are also both good ideas, as is a factory worker on the machine floor. Try to avoid visual clichés, such as someone pretending to write in a desk diary in an office setting, for example.

More to see

Although a close-up shot showing just the woman's head and shoulders would have made a perfectly acceptable portrait, standing back with a moderate wide-angle lens and including the factory environment produces an image that not only engages the eye, but also the imagination.

Gardener at work

The greenhouse here not only makes an appropriate background for the gardener, it also provides a good tonal contrast, separating him from the rear tree line.

A portrait posed in a rural landscape has obvious appeal, especially if the setting is attractive. But so many people live in urban areas, towns and cities, you need to think how to use these types of environment to good advantage, too. Consider depth of field (see pp. 16–19) – the background could be a range of hills or a row of tall buildings a long way off. Such a background might work well as a compositional device rendered softly out of focus though still clearly visible as a strong shape.

Equipment

You can use any lens for this type of portraiture, though a wide-angle or standard lens is most popular. Photo-journalists often use 21 or 24mm lenses, as images from these very wide-angle lenses look dramatic on the page, but watch out for distortion at the edges. With a 28 or 35mm

lens, the person appears to come forward in the composition but distortion should not be an issue. And because these lenses give an approximately similar view to normal vision, pictures have a natural sense of space and depth to them.

If daylight values outside are low, use fill-in flash or place a reflector where it can throw a bit of extra light into the shadows. Indoors, try flash bounced off the ceiling (see p. 59); professional photographers often prefer to use studio flash fired through a soft-box or into a special photographic brolly.

Reportage and candids

Reportage pictures are often taken with a wide-angle lens, even though photographers may risk life and limb getting close to their subjects. In this way they create a natural view of the world. These

Artist's studio

Choice of lens is crucial to make clear relationships between different elements within the frame. This photograph was taken with a 210mm lens, and you can see how this telephoto has enlarged the background comprising the artist's work, bringing it forward in the frame where it relates strongly to the artist himself.

images are not as controlled as the set-up portrait session, but you develop an instinct for who does, and who doesn't mind being in the frame.

Candids often work best when the subject is unaware of the camera, so hang back and bring the subject up large in the frame using a long telephoto lens, but use a fast enough shutter speed to avoid camera shake. Bear in mind that in some countries people have a cultural aversion to having their pictures taken, and local customs should always be respected

Portraits: Children

The most difficult aspect of photographing children is that they are always on the move. Setting a fast shutter speed (see pp. 20–3) will help to 'freeze' movement, but this may result in a compensating aperture too wide for the depth of field you want. Fill-in flash may help here – the extra light it adds will give you more exposure options. But bear in mind that the effervescent nature of the children themselves could well be lost if all movement is frozen, so experiment using a slow shutter speed – say, ⅛ or even ¹⁄₁₅ sec – to create some subject blur.

TIP

For more engaging, informal candid pictures, try sitting on the floor or squatting down so that the camera is at about the same level as the subjects' eyes. Pictures taken from an adult's standing position diminish the size of the children.

Once they are over their initial curiosity about you and the camera and lights, children will very quickly turn their attention back to their own friends and activities – and this is often the best time to start shooting.

Lens choice

If you want candid, informal images, take advantage of the physical distance a moderate telephoto affords you. A lens in the range 70–100mm (for 35mm cameras) allows you to hang back and move around the available space as you look for the best angles and shooting positions, while still filling the frame with a good-sized image of the subjects. A wide-angle lens is useful when you want to show subject and setting or, when used close up, to produce interesting perspective effects.

Candid approach
A child this young will happily amuse itself at play, taking absolutely no notice of you, as you wait, camera poised, for just the right arrangement of elements within the frame to occur.

Fast reactions
When the subjects are a tumbling ball of action, fast reactions are crucial. Ideally for this shot, it would have been best if all the children had been making eye contact with the camera, but two out of three isn't bad.

Portrait styles

Children are often photographed outdoors in a garden, for example, or local park. As attractive as these settings may be, care needs to be taken in bright, sunny conditions as colour film does not handle high contrast levels all that well – shadows may become dark and empty while highlights burn out to white. With static subjects, a well-positioned reflector can help even out exposure on the face by lightening shadows, as will fill-in flash. A white reflector gives a neutral (though contrasty) result, but to warm up skin tones use a gold-coloured type. A bright, overcast day, when there is less difference between highlights and shadows, often results in better-exposed pictures.

Portraits are often taken at formal occasions, such as christenings, a child's first day at school, birthdays, and so on, but why not be a little more inventive? Excellent images can come from the most ordinary of moments – your child's bath time, for example, napping after lunch, or quietly reading a book.

Older children tend to be aware of the camera, and of themselves, and so are more like adults to photograph (see pp. 82–3).

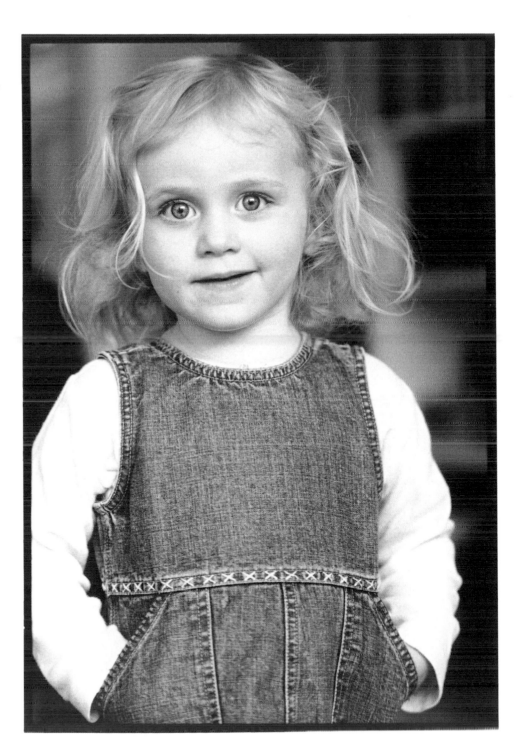

Timing is all

This image was taken at the very beginning of a photo session, and as you can see the subject hadn't yet lost her reserve – but curiosity was winning out. To counteract the directional lighting, which was casting unwanted shadows on her face, I positioned a simple white reflector, made out of stiff card, to reflect some extra light into this area.

Portraits: Group shots

Group shots can be tricky to take as you have to position everyone successfully in relation to each other while considering the background and how the lighting is affecting all concerned. A group portrait has many conventions going back through the history of painting and photography. Sometimes it helps to structure a group portrait by thinking about who looks most prominent, or who you might give the most prominence to.

In painting traditions, the group portrait was often commissioned as a public display of the status or wealth of a person or family dynasty, or as a celebration of the success of a group of people. The invention of photography in the nineteenth century made it possible for even quite modest families to have their portraits taken.

Studio photographers of the late Victorian era often posed family groups with the parents sitting in the middle and with their children standing, denoting the status of different family members of the time. It can be fun to experiment with how you arrange your subjects – do you emphasize age, seniority, personality, or importance, for example? Who is in the middle, who at the front, higher up in the picture, and so on. Play with the conventions and try to subvert them.

Photographers have produced whole bodies of work on the family group – famously Nicholas Nixon has photographed his wife and her three sisters every year since 1975. These pictures have become an exhibition and book, *The Brown Sisters*. They stand in the same order each year, and Nixon uses a 10 x 8in view camera. It is fascinating to see how the sisters change in each image, and it has become a powerful project about how people alter over a long period.

In magazines you see many group pictures – rock bands with the lead singer at the front and the other members arranged behind. A group of businesspeople will have the CEO in front or in the middle, and lesser beings arranged around him or her. Status aside, the person wearing the darkest clothes should be nearest the main light source, particularly if in the studio under flash lighting, as strong light on light clothes will cause them to overexpose or cause a tonal or colour imbalance in the picture.

To alter the eyeline, you could try standing on a chair or ladder so that the camera is looking down on the group – you will see their faces better this way, but you also imply they have a diminished status. To show an elevated status, drop the camera down slightly so that it is looking up at the subjects.

Not everyone has to look at the camera, so you can try changing the angles at which people stand. A team of winning rowers might look great all in a line at the award ceremony, but a group shot elsewhere might look too formal with people arranged shoulder to shoulder. Try each person standing with their weight unequally balanced between their feet – they will look more relaxed if standing slightly to one side. And if you don't have the advantage of the instant review facility provided by a digital camera, then take plenty of shots to safeguard against that one person blinking at the wrong time, and sort results out later.

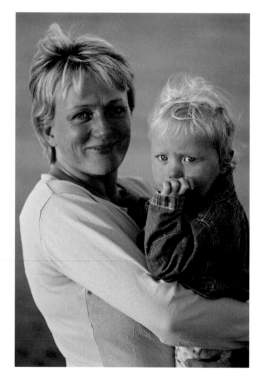

Telephoto lens effect
A zoom lens setting of about 180mm was used for this informal picture. It would have been possible to have moved closer and used a shorter focal length setting, but the telephoto perspective was perfect for isolating the subjects against a softly blurred skyline.

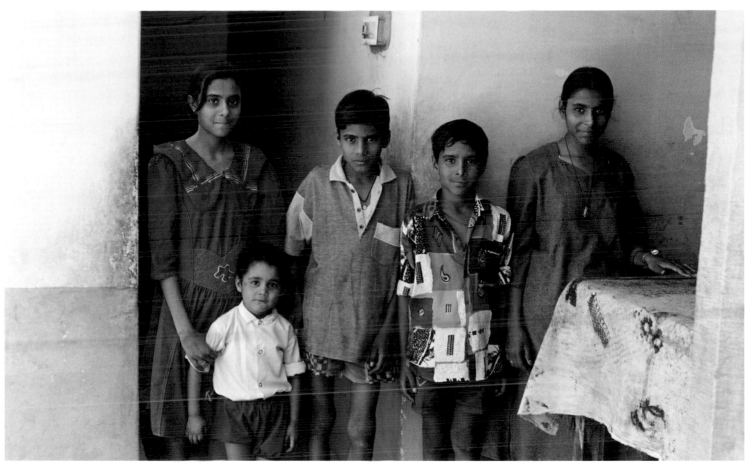

Formal arrangement

Part of the charm of this photograph (above) is the shy awkwardness of the subjects. Although the family asked to have this picture taken, they were not prepared to move away from their defensive position with backs firmly against the wall. With a digital camera, you can show your subjects the preview image on the built-in screen as soon as you have taken the shot, which is very useful for helping to break the ice and encouraging reticent subjects to relax.

Informal group

This icy, flat, windswept landscape (right) was not an obvious choice for a group portrait, but the stony outcrop, the only topographical feature for miles around, proved to be the perfect platform for this group of intrepid hikers to arrange themselves on. Without it, the photographer might have been reduced to organizing them unsatisfactorily into a seated row backed by a line of standing figures.

Landscapes: Rural

The term 'rural' suggests natural, unspoiled countryside, but in today's world it is difficult not to see the hand of man pretty well everywhere you point the camera. Even so, the theme is no less valid for all that. When photographing the landscape you are most particularly at the mercy of the ever-changing weather – and changes don't need to be dramatic to transform entirely the mood and atmosphere of your images.

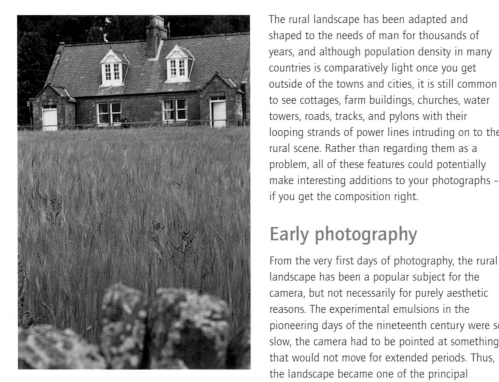

Depth of field
Use the visual qualities of a shallow depth of field to imply three-dimensional perspective and to help draw attention to specific areas of the frame.

TIP

You don't need to go to distant, out-of-the-way places or famous locations to find good landscape photographs. A landscape isn't just a scenic view – think about all the elements in front of you and how to get the best image through composition, shooting position, focal length, and so on.

The rural landscape has been adapted and shaped to the needs of man for thousands of years, and although population density in many countries is comparatively light once you get outside of the towns and cities, it is still common to see cottages, farm buildings, churches, water towers, roads, tracks, and pylons with their looping strands of power lines intruding on to the rural scene. Rather than regarding them as a problem, all of these features could potentially make interesting additions to your photographs – if you get the composition right.

Early photography

From the very first days of photography, the rural landscape has been a popular subject for the camera, but not necessarily for purely aesthetic reasons. The experimental emulsions in the pioneering days of the nineteenth century were so slow, the camera had to be pointed at something that would not move for extended periods. Thus, the landscape became one of the principal themes for Victorian photographers, especially once the railways opened up the countryside for travel, and film emulsions improved, enabling fine detail to be recorded.

Lens choice

Wide-angle lenses are ideal for capturing broad sweeps of countryside. Lenses in the range 28–35mm (for the 35mm format) should produce distortion-free images, with no obvious bowing of vertical lines towards the edges of the frame – a problem common with some very wide-angle optics. Even though edge distortion is a potential problem, some photographers favour 18mm lenses and even wider for landscape work, though it is then a good idea to look for some prominent feature in the foreground that you can emphasize. Otherwise, everything in the scene may look very small, distant, and unengaging in the resulting images.

You also need to bear in mind that the wider the view taken in by a lens, the less likely it is that a single exposure setting will successfully record all of it, so choose your shooting position with care to avoid extremes of over- or underexposure in different parts of the frame.

The magnifying qualities of telephoto lens come into their own when you want to make distant details larger in the frame, or you want to look beyond a foreground that is not adding much to your picture's impact. And the more restricted angle of view (compared with a wide-angle) is also extremely useful to help you crop out unwanted elements of the scene to give, if that is your intention, a more idealized view.

If you are using a zoom lens – a wide-angle or a telephoto zoom – it is always worthwhile varying the focal length just a little around your

chosen setting while looking closely at the edges of the frame, just to see if the composition could be improved in any way.

Formats

All camera formats can be used successfully for the rural landscape. Unless you are after a moody, grainy result, the normal choice of film is a fine-grain emulsion, around the 100 ISO mark, and a tripod is also recommended as you will then have the option of stopping the lens right down for maximum depth of field and using a very slow shutter speed to compensate.

Apart from the inherently higher quality of rollfilm and sheet film, the other thing to be said in favour of medium-format and larger cameras for landscape work is that they can be slow to use, and it is this slowness that can encourage the photographer to take a more studied, measured approach.

Lighting quality

The quality of the natural daylight falling on the countryside varies according to the time of day and the time of year. Many landscape specialists prefer to photograph in the early morning or towards dusk and early evening to take advantage of the low angle of the light and the lower contrast levels this brings.

Mist and cloud can also give a soft, atmospheric light, and if you are shooting in black and white, a yellow filter gives a dramatic cloud effect with blue sky on a sunny day (see p. 33). For those shooting on colour film, a polarizing filter can intensify the blue of a sky as well as removing, or at least minimizing, reflections from the surface of any water that may be in the scene.

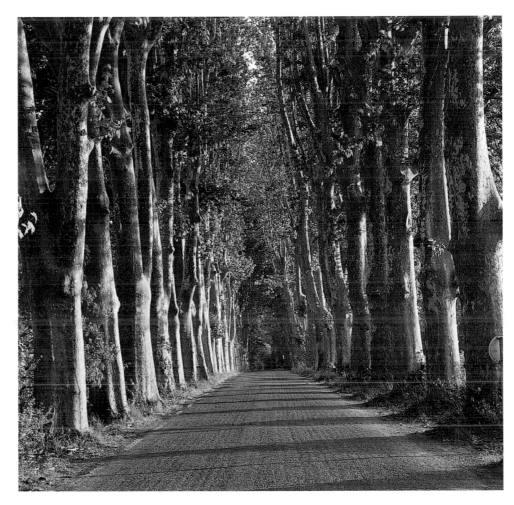

Vanishing point
The central camera position has been used here to emphasize the distant vanishing point. But the impact comes from the tall, closely planted corridor of tree trunks, creating alternating bands of highlight and shadow.

Graphic contrast
Reeds protruding through a covering of snow make a simple yet powerfully graphic image that speaks of the cold and quiet and isolation of winter.

Composition

The rural landscape naturally lends itself to abstraction, no more so than when the patterns of fields can be seen from some high vantage point. Look out for features you can take advantage of, turning the wall of a high castle turret, for example, into a convenient camera platform. Be careful with film exposure, however, if your meter indicates too high a contrast range between the land and sky elements of your composition. If there are many f-stops' difference you may want to adjust framing to remove, or at least lessen, the presence of one of these elements in the picture area. Alternatively, try using a graduated filter to darken the sky, or a graduated neutral-density filter, which will darken the sky without changing its colour in any way, to help even out exposure across the frame. This technique is also useful with black and white film.

A wide-angle lens emphasizes the foreground, and so helps balance the sky. Look for lines, such as tracks or hedgerows, that will disappear to a vanishing point. And think how you can emphasize space and depth in your pictures, and where you place the horizon or some other notable feature (see pp. 42–7).

There is a tradition in black and white photography that uses abstraction as a way of portraying feeling. Try cropping out the sky, to abstract the picture, and look for graphic qualities of shape, tonality, and light and shade in the subject. You can experiment with ambiguity of scale, with a detail of a sand dune looking like a mountain side. And you can find natural still-life arrangements at your feet if you take the time to see what is there.

Abstraction

Revealing just a detail of the landscape is the perfect way to create abstract imagery. The sense of abstraction has been increased in this picture by the photographer's deliberate choice of a shutter speed that is just slow enough to record movement as blur.

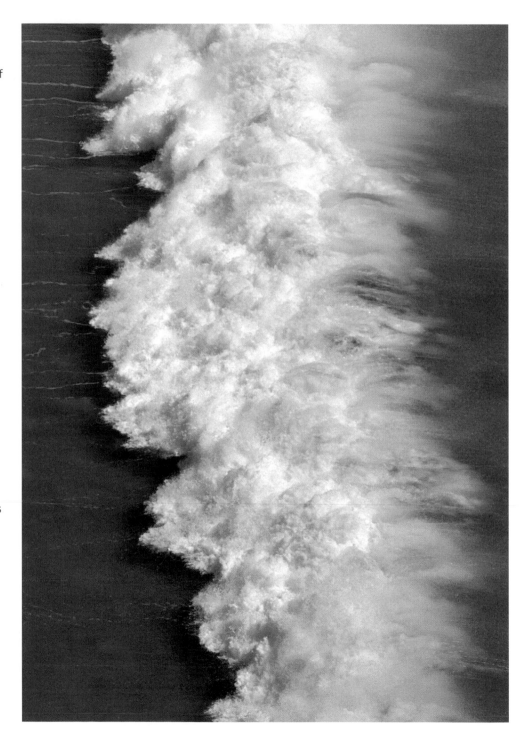

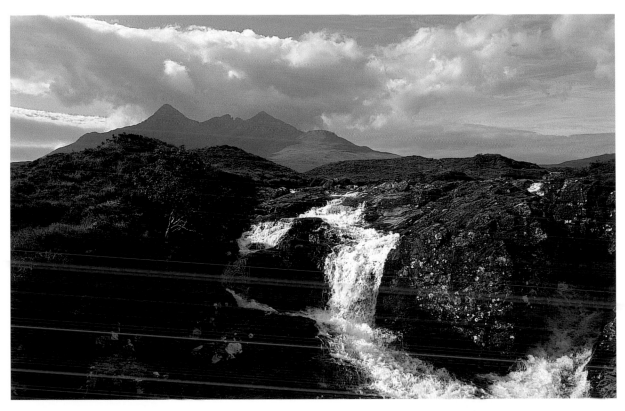

Graduated filter
A graduated filter was used here (left) to reduce the sky exposure by 2 f-stops and help to balance the overall exposure.

Lighting contrast
High-contrast light (below left) has transformed this black and white landscape into a scene of beaten silver.

Unconventional take
Convention has been turned on its head (below) by removing the sky from the image and showing it only as a reflection in the still, blue water.

Landscapes: Urban

Most of us live in or visit towns and cities so they are obvious environments to explore. Look for juxtapositions of new and old, contrasts between innercity settings and leafy enclaves, and do not forget that often it is the human element that makes the urban landscape so rewarding to photograph.

Types of subject matter

As film emulsions began to improve and exposure times grew shorter, the city became a favourite subject for photographers. In the latter part of the nineteenth century, photographers began making records of the overcrowded tenements, factories, and other sources of social problems.

Decay in cities, typified by graffiti, dereliction, traffic congestion, and pollution, is a common thematic approach. On a more positive note, many modern buildings, squares, recreation areas, bridges, and road systems have improved the quality of the urban environment and can make fascinating subjects for the camera – especially when you find shooting positions that contrast the new with the old.

A visual trick that always works well is to show a traditional building reflected in the gleaming glass of a modern building. A different take on this, however, could be to show the reflection of a modern, glass-fronted tower broken up and fractured in the small, glazed window panes of a much earlier building.

One of the choices you need to make is whether to include people in your images, and, if so, how to depict them – perhaps in relation to their surroundings, adding a sense of scale. An alternative approach is to turn the camera away from the broad urban landscape and concentrate instead on your local neighbourhood or street.

The work of Bernd and Hilla Becher, from the Düsseldorf Academy in Germany, is worth

Subject planes

The subject planes in this urban scene are well defined. The foreground is firmly anchored by the silhouetted tree, which acts as a frame for the figures in the middle ground who, in turn, provide scale for the background buildings. Cover up the tree with your hand and you will see immediately that the picture loses all sense of depth and looks very two-dimensional.

looking at if you are interested in the urban landscape. They have specialized in photographing industrial architecture for the last 40 years in both Western Europe and North America, producing a body of outstanding work featuring houses, water towers, and the mechanized environment.

Composition and approach

Think about viewpoint and use local features to achieve your vision. For example, photographing from a high vantage point can be very effective, revealing shapes and patterns of development invisible from the crowded eyeline of the street, where it is often impossible to stand back and really see your surroundings. If a convenient hill is not available to give this much-needed height, think of alternatives, such as a rooftop or a window or balcony in a high-rise building.

Urban images, because of their angles, vertical lines, and pattern, also lend themselves to graphic abstraction. A wide-angle lens can exaggerate shapes, while a telephoto flattens the sense of space, foreshortening a row of houses, for example.

The quality of light is as important in an urban setting as it is in a rural one, but often the close proximity of buildings, billboards, and other street clutter can produce pockets of deep shade and bright highlight. One way around this is to exploit the high contrast by shooting against the light to create graphically powerful silhouettes.

High viewpoint
Bright overcast lighting and a high vantage point (above right) have transformed these suburban rooftops into a series of abstract shapes.

Storm light
As storm clouds gather in the sky over New York's Greenwich Village (right), the sun breaks through to produce a dramatic scene full of graphic shapes and sharply contrasting tones. The sunburst reflection high up on the building provides a striking focal point.

Travel photography

Perhaps the best advice for successful travel photography is don't take pictures as a tourist might – always try to find a new slant on what might be an obvious site, landmark, or event. A good travel photographer, like a good travel writer, will be drawn to the ordinary life of a place just as much as to the more famous sites. Some research is needed before you go anywhere new so that you can make the best of the trip, planning an itinerary that does not waste valuable time.

In places such as Asia, India, and Africa, where tourists are still often regarded as a welcome distraction, it is not unusual to find yourself mobbed by local children, especially outside the large cities and towns. The children often make willing subjects for the camera, if you take the time to notice them. All too often, however, embarrassed tourists, perhaps with a busy guide to keep up with, simply push their way through these crowds with eyes averted. Telling pictures of adults can be more of a challenge, but displaying an open, friendly attitude is certainly a good start. However, don't insist on taking pictures if you are waved off. A telephoto lens will be good for an individual face shot, but a standard or wide-angle can help put the person in context.

Try to capture the essence of a place, such as the quality of the natural light, the architecture,

TIP

At all times be a good ambassador for your own country and tourism at large, and remain aware of local sensitivities when it comes to taking photographs.

A good-natured welcome

Rather than pushing your way through a crowd of enthusiastic children, take the time to run off a few pictures. You are likely to be jostled somewhat, so set a fast shutter speed to reduce camera shake. It's a good idea to take handfuls of pens and coloured pencils to countries like Africa or India, as school supplies can be expensive and difficult for locals to obtain.

designs, and colours. Sometimes, details are better than wide views – an inlaid Mogul wall decoration may be more interesting than a straightforward postcard-type shot of the Taj Mahal; a single taxi, street sign, or doorway might capture the essence of a foreign city more than a famous ceremonial arch or grand palace.

Things to remember

Take enough film (or memory cards) and batteries with you, as it may be difficult to buy exactly what you want in other countries. And film should be kept as cool as possible if you are travelling in hot climates. Keep unused film in your hotel room refrigerator (if available), but allow it to come up to the background temperature before loading it into the camera. In very cold climates, batteries run down more rapidly than you may be used to, so take extra if this may be a problem.

Digital photographers can download images on to a laptop or portable hard-disk to free up space on memory cards, and digital picture files can even be sent home online via a landline or mobile phone connection.

But no matter which type of camera you use, keep lenses and filters free of grit, grime, dust, and fingermarks at all times. And for very dusty conditions take a tin of compressed air for cleaning external and internal camera surfaces.

Day-to-day life
While travelling, keep an eye out for distinctive aspects of people's lifestyle. In Norway, the photographer was fascinated by this sleigh-cum-walking frame (above right), which was pressed into service as a shopping cart and, sometimes, child buggy. New sights become commonplace surprisingly quickly, so take your shots before the novelty of the situation fades.

Big skies
Lowering the horizon in this image (right) brings home to the viewer just how much the sky dominates the western landscape of the United States.

Caribbean paradise

When you find a perfect scene like this, make yourself comfortable, frame up the shot, and wait for that finishing touch – a little sailing boat to come into view, perhaps? And use natural features to improve the composition. Here, the tree branches not only helped to add depth and distance by creating a foreground-background contrast, they also covered up some beach-side development that detracted from the view.

TIP

When changing film, find a shady area before opening the film pack. With both digital and film cameras, avoid exposing any interior parts to wind-blown sand, dust, or grit.

Central Park, NY

Certain scenes are so typical of a particular place that they simply must form part of your photographic record. This picture shows New York's Central Park at lunch time, and it is a fascinating illustration of how New Yorkers respond to the concept of personal space.

The Parthenon, Athens

If you want to photograph a famous monument – such as the Parthenon on the Athenian acropolis you can see here – free of the thronging crowds of tourists, get up early when there are fewer people about, and use the restricted angle of view of a long lens to show just a telling detail.

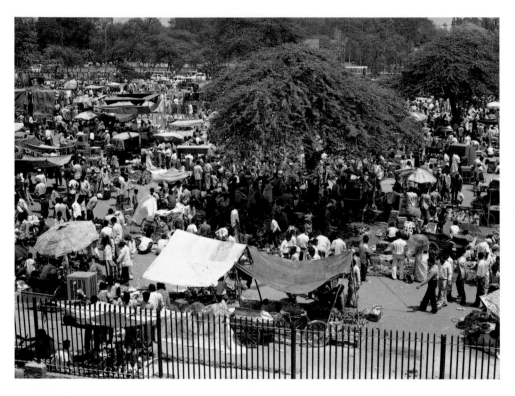

Establish the location

Images such as this, taken from a high vantage point, are very useful as establishing shots, giving an overall view of the scene – a busy market in southern India.

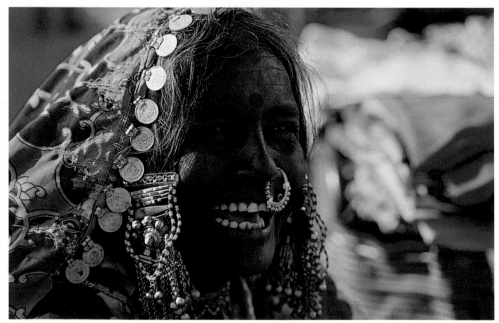

Capture the detail

This candid portrait of a stall holder at a market in Goa, southern India, was taken with an 80–210mm zoom lens set at about 180mm. Her colourful costume and jewellery ensured she received pretty constant attention from passing photographers.

Telling details

Sometimes, detail can provide you with new insights into the familiar. This photograph shows a detail of the intricate and beautiful stone inlay ornamentation of the famous Taj Mahal, which is usually depicted from a distance with its familiar domed edifice, corner spires, and foreground lake crowded with tourists.

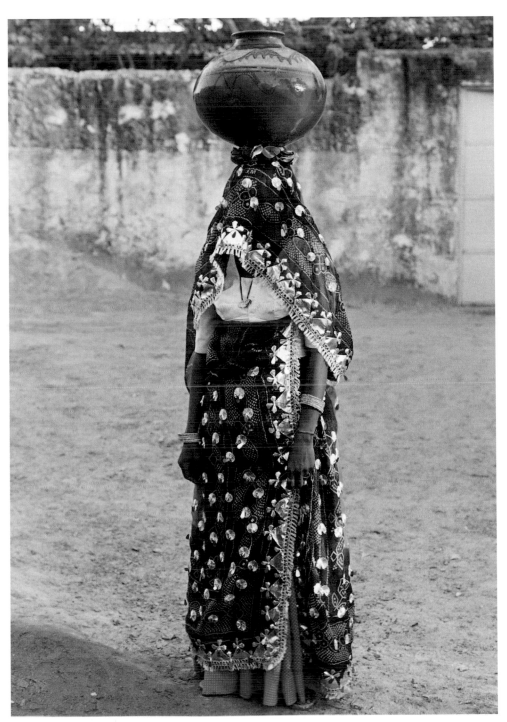

Local differences

Although Hindu women do not normally react to the camera by lifting a veil to cover their faces, in Rajasthan in the north of the county, centuries of rule by Muslim moguls have left their mark on local customs.

Still-life

Because of the painfully slow speed of the early emulsions, still-life subjects had an obvious appeal for photographers in the pioneering years. And even today, this subject area remains a contemplative, methodical way of working, requiring skill in setting up the subject elements, and also a sharp eye for ensuring that objects work well together and with the background.

From catalogue shots of products of every description to pictures showing displays of craftwork and objects for designers and museums, not forgetting the enormous range of images required by the advertising industry, there is an insatiable appetite for commercial still-life photography. In addition, art photographers have always been attracted to still-life as a creative outlet.

Studio equipment

Commercial photographic studios use a wide range of different styles of lighting, tailoring each to suit the needs of the product. For example, soft-boxes scatter and diffuse studio flash lighting (see pp. 37 and 59). These can be placed at any angle to the subject, but a popular position is above the subject, looking down. A white background produces a good, clean image, while a graduated background gives the illusion that the light is falling off.

Photoflood or tungsten-halogen lamps are a cheap entry point to studio lighting, but they do produce a contrasty type of illumination that is not necessarily sympathetic to still-life subject matter. These lamps also give out a lot of heat and are uncomfortable to work with closely. In their favour, the continuous light output means you can see exactly the effect the lighting is having on the objects and how shadows are falling within the picture area.

A tripod (see p. 39) helps with framing as you can stop the lens right down to maximize depth of field and then set as slow a shutter speed as you need to compensate without worrying about camera shake. And with the camera on a tripod you can leave the shooting position to adjust the different elements of the still-life composition, coming back to a fixed point each time to check the results through the viewfinder.

Working close up

Moving in close and setting the lens to its minimum focusing distance concentrates the mind on the subject wonderfully by removing all extraneous detail. Depth of field is very limited here, barely covering the top surfaces of the pomegranates, and the lighting is daylight entering through windows on the left of the camera with a reflector on the shadowy, right-hand side to lower contrast a little.

TIP

Shooting with colour film in daylight, you may need a warm-up (81A) filter as some brands produce a bluish bias in soft light.

Found or constructed subject matter

Daylight is a versatile, readily available light source for still-life photography, whether the subject is a 'found' one you have simply come across or a 'constructed' one you have set up for the camera. The found still-life is the result of good observation, as you need to recognize the pictorial qualities in ordinary objects. The constructed still-life is a test of your ability to translate your vision into a composition built up piece be piece, one in which objects create new meanings and juxtapositions.

Think about the varied aspects of photography you can bring to bear on the subject. First, consider viewpoint - do you look down on the subject and simplify the background or shoot from somewhere around the periphery? Then there is lighting quality - do you use a soft or contrasty form of light? Next, think about lens focal length - do you move in close and use a macro setting or shoot from further back with a telephoto setting? And finally, what about depth of field - do you select a large or small lens aperture?

Overhead view
Adopting a camera position looking down on the subject is the ideal way to simplify the background.

Observation
In frosty weather in winter, when the ground is covered in leaf litter, we walk past scenes like this a dozen times a day, seldom recognizing the pictorial possibilities at our feet.

Suitable frame
The ragged black border to this still-life composition makes a sympathetic frame for the tangle of root encompassing the bowl.

Plants and gardens

Gardens have an obvious beauty and have been much photographed since the start of photography. French photographer Eugen Atget's photographs of Versailles taken in the early 1900s feature strong formal shapes, and compositions that perfectly capture the imposing geometry of the gardens. Modern garden photography is more likely to concentrate on recording informal, naturalistic drifts of plants contrasting with stone and wood.

TIP

When taking close-up plant studies, a reflector helps ensure that important subject detail is not swallowed up in shadow. A gold-coloured reflector works well with colour film, as it warms subject hues.

Although colour film is the obvious choice for capturing the colour and vibrancy of flowers and foliage, and the terracotta and glazed hues of pots and containers, black and white can also be successfully employed to record shape, pattern, form, and texture. And once stripped of their colour, plants with strong shapes can make wonderful compositions in black and white. To see a master of the art, look at the work of Karl Blossfeldt and his series of sculptural plants in black and white set against simple backgrounds, taken in the 1920s.

The changing light, the vagaries of the weather, and the yearly cycle of growth and decay are all good subjects for anyone interested in garden photography. Linked to this, you also need a combination of botanical understanding and a good sense of composition and design.

The right light

Strong sunshine at the middle of the day is generally not the best time for most garden photography, as contrast is high and the intensity of the light leaches colour saturation. Although the screen on many digital cameras is not the most accurate way to view colour and contrast, it does at lease give you a pretty good indication of what your final image will look like.

Experienced photographers favour a slightly overcast day for garden work as then there is less contrast. Early morning or dusk light can also be good as, at these times of day, the low angle of sunlight across a garden can produce amazing backlit effects.

Different approaches

To show an overview of a garden's design and structure, look for a high shooting position, such as an upstairs window, and use a wide-angle lens. To contrast with this broad-brush approach, look out for possible subject matter in details, such as flower heads, the texture of peeling bark, and design details like ornaments and water features. Sculpture can be a feature of any garden, and it adds a valuable focal point or contrast between the natural and constructed elements.

A medium- or large-format camera is well suited to this subject area, especially when fine-grain results are essential.

Public and private gardens

Bear in mind that you may need permission to photograph in some gardens, and some well-known gardens even charge a fee, especially if photographs are intended for publication. Visitors are often permitted to take pictures without a fee as long as they do not use a tripod (a tripod is taken to denote a professional photographer).

Be selective
The impact of both these images (above right and right) comes from the selective eye of the photographers.

Black and white view
Choose the right viewpoint and gardens easily translate into black and white (opposite). A close-up light reading from the flower head was used as the basis to expose the whole frame, thus creating a punchy, low-key image.

Shooting angle
This shooting angle proved to be the best available as not only did the flowering plant fill the foreground, it also completely masked the presence of a group of picnickers on the lawned area in the middle ground.

Sculpture garden
In this sculpture garden, owned by the English painter and film-maker Derek Jarman, the pieces of art have been treated as if they were shrubs and bushes, 'planted' in among the living specimens. Linking all the garden elements together is a layer of chipped stone.

Backlighting

By adopting a low shooting position, with the camera right at the base of the plant, it was possible to use the leaves to mask the direct sunlight coming towards the lens. The fringe of highlight around each long, strap-like leaf is typical of backlighting, and occurs when light begins to flare slightly to form a halo of illumination.

Afternoon sunlight

A low, late-afternoon sun spotlights this colourful seating area in a private garden. At this time of day, much of the strength of the sunlight has dissipated and the illumination takes on a warm-coloured hue perfectly suited to garden photography.

Special effects

Here you are invited to break the rules. Instead of avoiding camera shake, try exploiting it for creative effect. Try drawing on or scratching unwanted negatives or prints (especially colour ones). Old-fashioned and unusual materials can be a rich source of interesting imagery and, of course, there is also the digital world of image manipulation to explore.

Cyanotypes

The cyanotype technique dates back to the nineteenth century and is not unlike a photogram in its effect (see pp. 114–15). Lay your materials – here a leaf and flowers have been used – over some specially coated paper and then place the paper in sunlight. Next, rinse the paper in water, leaving the background blue colour behind and the plant shapes in white.

To the experimental and creative mind, aspects of conventional photography might be seen as a little unsatisfying. If so, there is no harm at all in using the photographic image not as the end product but rather as the starting point in the creative process, and degree shows and art galleries are full of the best results of this process. It may seem strange that students sometimes employ the most up-to-date and sophisticated cameras and lenses, only to break down the fine-quality images they produce by scratching, bleaching, or otherwise chemically transforming the final print.

Solarization

The American photographer Man Ray discovered solarization by accident when his assistant turned on a white room light while he was processing a sheet of film. This is a difficult technique to reproduce with film – especially rollfilm or 35mm – and is easier to control with a print. For film solarization, partway through the development stage, flash the room light on and off to expose the emulsion to white light. Finish the processing sequence as normal. At the end you should have a mixture of positive and negative elements as some areas that were light go dark, and there should also be an outline of film fogging around lines and shapes in the picture.

For print solarization, take the print out of the tray halfway through development and expose it to white light under the enlarger for about 2 sec. Continue processing and the white areas will go dark, but the already developed image will remain.

Slide projections

A simple special effect is to project slides on to a person or object and then photograph the result. Anatomical drawings overlaying a nude figure may be effective or an old family photograph may have poignancy if projected on to a wall in your home. You can control the size of the image by adjusting the projector lens's focal length, but bear in mind that unless the surface used to carry the image is completely flat, it may not be possible to keep it all in focus.

Lith developer

Lith developer is intended to produce high-contrast black and white effects, but if you dilute the developer 1:9 with water, the grain of the image is emphasized and it takes on this warm colouration.

Negative sandwich

Another special effect involves placing two black and white negatives together in the carrier of the enlarger, and exposing them as normal. The result of this is that the detail of one will show through in the clear (shadow) areas of the other. You could take pictures specifically for this technique, with different but sympathetic scales – perhaps a close-up of an apple and a person's face, for example. When printed together, the face could appear within the shape of the apple. Because of the combined density of the two negatives, you will have to experiment to discover the new exposure time required for a satisfactory print.

Overlaying texture

To create this very painterly effect, all you need do is sandwich a single sheet of tissue paper with a negative in the enlarger's negative carrier. When exposed, the texture of the tissue overlays and transforms the photographic image.

Scratched negative

This effect was created by lightly scoring the emulsion side of a negative with a pair of scissors and then producing an ordinary print. With an image such as this, take care not to scratch any of the actual subject detail. Needless to say, this is an irreversible procedure, so use only an unwanted or duplicate negative.

Night photography

Night photography is a technique that demands the use of a tripod for shake-free pictures (see left). With the camera secured, you can point the lens at, say, a night-time street scene and record all stationary parts of the view by the light of the moon, street lights, house lights and so on, while approaching car headlights and receding car tail lights turn into bands of elongated white and red. A medium-speed film is best, around 400 ISO, and you need to choose an aperture around f5.6. Very small apertures, although increasing depth of field, may result in over-long exposure times. Most light meters will not be suitable for night-time photography so make a series of exposures of the same subject using a variety of manually timed shutter speeds. Start off using 6 sec and make further exposures adding 2 sec each time. Experimentation is the key here.

Double exposures

Most cameras are designed to prevent you exposing the same frame of film twice, but camera double exposures are possible. What you must do is press the button (usually on the camera's baseplate) that releases the film take-up spool as you wind it on. This way, the shutter is cocked ready for firing, but the film remains

Night photography
This night-time shot of beach huts (above left) is pin-sharp despite a 2-min exposure. Note that parts of the scene lit by hidden light sources record well, while the visible background streetlamps are surrounded by enormous envelopes of light.

Light trails
For this style of light trails (left), take the camera off its tripod, hold the shutter open, point the lens at some likely light sources, and move the camera about so that you are effectively 'drawing with light'.

Double exposures

The gravestones image (above) had two normal exposures on one negative, but the camera position was changed slightly the second time around. The portrait (right) was shot against a black background so the face would stand out. The outer shots have the subject looking towards a flash soft-box; the middle image was lit from the side. Each was given a full exposure time.

stationary. With more automated cameras, you may have to shoot the whole roll, rewind, and then take another full set of pictures on top. The frames probably won't match exactly, but you might like the effect. If your subjects are against a dark background try giving each frame the full exposure time indicated by your light meter. But with subjects against a bright background, try halving each exposure.

Camera shake with flash

This image exploits camera shake to good creative effect. A very slow shutter speed has caused a general blurring of the image, but a sharp image, formed by firing a flash partway through the exposure, is also present.

Digital imaging

Modern software packages offer the digital photographer a wealth of image-manipulation possibilities. Though many of the menu options may have names you recognize from the darkroom, the results of the digital versions may not necessarily have the same appearance. And bear in mind that the radiant image you see on the monitor screen may not be reproducible as an ink-on-paper output.

It would be foolish to try to introduce one of the best-known programs, Photoshop, in the space available here, but if you get the opportunity to experiment with a copy on a friend's computer or a computer in a college or night school, you will quickly see the possibilities on offer.

The images on these pages were created in seconds – at the proverbial 'click of the mouse'.

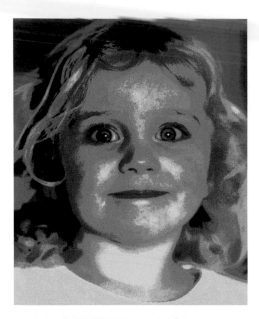

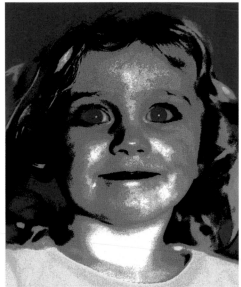

Posterization

To create the effect in the set of portraits here (right), try taking your original image through the IMAGE>ADJUST> POSTERIZE menu. Choose a number to alter your image to a posterization effect not unlike an Andy Warhol screen print.

Digital filters

For a set of alternative architectural studies such as these (opposite), experiment with the FILTERS option. There are literally dozens to choose from. It is pretty obvious that electronic filters have little in common with their traditional counterparts.

Original image, scanned but unaltered

Solarization filter

Coloured pencil filter

Pinch filter

Photograms

Photograms are photographic images created without the use of a camera. They are made by placing objects on printing paper and exposing them to light. Objects in direct contact with the paper will have sharp outlines – flowers and leaves, for example, can be pressed flat with a sheet of glass. Irregular materials that stand proud of the paper, or that let light through, will create images with shades of grey.

TIP

To create photograms with shadows, shine torch light from the side rather than using overhead light from an enlarger.

Some of the first experiments by Fox Talbot in the 1830s were with photograms – flowers, leaves, and pieces of lace placed over specially treated paper and left outdoors in the sunlight for long periods with the objects and paper pressed tightly in contact in a glass-fronted wooden printing frame. Anna Atkins created flower and plant pictures in much the same way, but using the rich blue cyanotype process (see p. 108).

In the 1920s, at the Bauhaus school of art and design, in Germany, a tutor, László Maholy-Nagy, encouraged an experimental use of photography. He himself made photograms that were very abstract in content, exploring shape and form in unusual ways.

Baby pictures
This perfectly safe twist on a traditional baby picture was created by placing the child on a large piece of photographic printing paper and turning the enlarger light on.

Technique

Making photograms is similar to making a contact sheet (see pp. 68–9), as you don't need an enlarging easel. Instead you can place the printing paper directly on the baseboard, or you could use a home-made contact printing frame or just a large sheet of glass.

Set the enlarger head so that the light covers the area where the paper will be. Stop the lens down 2 stops from maximum, and put in a multigrade filter. The contrast of the print is determined by how well the object excludes light from the paper. If the object excludes light totally, the photogram will be just black and white, and appear contrasty; if it lets light through, however, it will have mid-tones and appear softer.

Use a test strip to work out the exposure, with the object lying over the paper, and select the exposure time that renders the background black, and then make your full-sized prints.

Digital

Place objects on the glass of a scanner and scan them to create a digital file. You could make a collage featuring a portrait picture with material arranged around it. Make sure the photograph is totally flat, otherwise light reflected from the photograph may cause unwanted distortion.

Test strip

If you want to ensure you have a completely black background to your photogram subjects – here poppy seed heads (see left) – expose a test strip first (above). You can see distinctly the difference in tone resulting from the different exposure times.

Shadow effect

This shadow effect was created by exposing an egg shell on a sheet of printing paper using the light from an ordinary torch held low down. It makes an interesting variation on a theme.

Photo-reportage

An honourable photographic tradition, photo-reportage is a picture or a sequence that tells a story or records an event. It could also be coverage of a documentary topic. It might have a narrative, with a beginning, middle, and an end, or it could show a political rally, publicity event, or a wedding.

The term photo-reportage describes the process of recording a particular situation as it unfolds. The pictures are often candids, or at least unposed, but some may be set up, with interaction between photographer and subject. Henri Cartier-Bresson's work could be described as photo-reportage (see pp. 48–9), though not necessarily of the narrative type, being a personal interpretation of people and places.

Photo-reportage suggests the great picture stories from *Time-Life* magazine in the 1940s and 50s, in the era before mass television, but also the personal projects of many well known photographers, such as Robert Frank's *The Americans*, carried out over a two-year period in the early 1950s. The tradition also includes the many good projects seen today in exhibitions and in weekend magazines.

There are types of picture that work well to build a photo-reportage series. A general view of the place, or event, taken from a high vantage point, or with a wide-angle lens, for example, puts the story into context, while shots of the main people and important moments are the real meat of the story.

'A day in the life'

This was a popular picture-story theme in the 1950s with a photographer showing moments in someone's daily life – at home, at work, and at play. Eugene Smith was the great exponent

of this style of photo-reportage, and his stories, including *The Country Doctor* and *The Spanish Village*, are classics.

Today, the 'fly on the wall' approach is popular with both television documentary crews and stills photographers alike, showing behind-the-scenes shots of institutions or celebrities. If this is of interest, you could devise a project on a place or a person you know and produce informal, behind-the-scenes pictures, or cover an event such as a festival, a performance, or even a wedding.

Party time

Previews at art galleries, exhibitions, press events for the launch of new products, social events where notable personalities will be in attendance, political gatherings – these are all situations where you are likely to find press or freelance photographers looking to snap interesting combinations of people. Sometimes the subjects of these pictures are unknown to the photographer at the time, but the image goes into the files where it may emerge months later as the key component in a story.

Poignant moment

Work quickly and discreetly when, in situations such as this, the camera might be seen as an unwelcome intrusion. These two Chelsea Pensioners, who had seen action in the Second World War, are pictured in front of a display board of soldiers who never came home from the Great War. The old soldiers are shown at the opening of a new reception centre at a war cemetery in France.

Timing

The essence of a good photo-reportage picture is that it should sum up an event or situation, telling a story through its visual content. To achieve this, you have to stay alert for that special, unpredictable moment when everything comes together in perfect harmony. Here, the photographer has captured that moment during an elephant parade through a New York park when one of the elephants stretches out her trunk towards a ripe, red apple, much to the surprise of a passer-by.

An industry in decline

Photographs such as these, of fishermen sorting out their catch and maintaining their nets and boats, could be part of a sequence of images dealing with aspects of the fishing industry. Periodically the plight of fishermen becomes big news, linked as it is in the minds of the public with issues of sustainability and declining fish stocks, and with social issues relating to the decline of traditional fishing communities as fleets of boats are bought up and decommissioned.

Weddings

The photographer has a big part to play at a wedding, making a complete record of the day and choreographing group pictures and set-pieces. Many people choose a mixture of formal shots and fun candids for their album, so you have to work hard and not be afraid to take charge.

When it comes to getting the pictures you need, experience is crucial. Be prepared to shoot extra film and take your time until you are happy. Guests usually will not mind waiting, as they will be taking their own pictures, too. On a sunny day, use fill-in flash to lighten shadow on faces and keep exposure more even across the frame.

Candid pictures will look more natural than the set-pieces, but also go for informal, semi-posed shots – people usually love playing up to the camera at events such as weddings. You might use a 35mm camera here for its easy handling,

Two cameras

If the bride and groom are agreeable, take a mixture of colour and black and white images. If you have two camera bodies, load each with different film and then swap lenses as necessary.

and a telephoto zoom will be good when you don't want to intrude by moving in too close. A wide-angle lens, as long as it is distortion-free at the edges, is the best option for large group shots.

Close-ups

A close-up can make an ordinary subject look extraordinary. A feature of photography is that it allows us to play with scale, and this has given us fantastic images of massively enlarged insects or abstract patterns of crystalline structures seen through a microscope. A close-up could also be a simple detail of a person's body or a baby's hand or foot.

TIP

Close-ups create a shallow depth of field, so you may need apertures of f22 or even f32 to keep all your subject in focus. A tripod will be necessary because of the slow shutter speeds these apertures demand.

Special equipment

Many 35mm zoom lenses, such as the 35–80mm, that come packaged with SLR cameras have a 'macro' setting. Place the lens in macro mode and the internal elements of the lens reconfigure and give you a single, fixed focus setting that is much closer to the subject than the normal focusing range would allow. The best way to use this facility is to set the lens to macro and then, looking through the viewfinder all the while, move the camera closer and closer to the subject until you see it snap into focus. The macro facility on a general-purpose lens may not go as close as a true macro lens. This lens has a fixed focal length, a complicated internal construction, a small maximum aperture (often reaching f32) to help with depth of field, and is very expensive.

Another close-up option is to fit an extension tube between the camera body and lens. This permits an ordinary lens to focus closer than a macro, but a macro lens plus an extension tube will get you very close indeed. Tubes come in sets of three different sizes and can be used in various combinations. Not having glass elements, they are inexpensive to buy and through-the-lens (TTL) metering systems should automatically make any exposure compensation that is necessary.

Tubes work with medium-format SLR cameras, where image quality can be amazing. The rollfilm Mamiya RZ67 has a built-in bellows to extend the

Moving in close

The first picture (top), of studs on a rusted background, was shot using the macro setting on a zoom lens. For the next two shots, of rubber bands and a wall hanging (above left and right), extension tubes were used with an 80mm lens.

lens forward for close focusing. Large-format cameras also have a bellows to extend the lens forward, and extra bellows units can be inserted between the lens panel and film for extreme close-up images.

Supplementary lenses in the form of special lens filters are the cheapest type of close-up accessory. These screw into the front filter mount of the lens but they are not as good or as flexible an option as tubes. Bellows units for 35mm cameras are available, but they are expensive and not commonly used.

Lighting and metering

When the lens is very close to the subject, lighting tends to be a problem. To counter this, ring flash, which sits around the front of the lens (see p. 36), delivers soft, shadowless illumination over short distances. This type of flash is commonly used in medical photography, but is also used for some styles of fashion photography and portraits. It is not designed to work over long distances, however, so always keep within its intended range. A crucial advantage in using electronic ring flash is that you can use daylight as a supplementary lighting source without worrying about colour casts.

The TTL exposure metering system in an SLR camera will compensate for the light lost when using a lens at its macro setting or with extension tubes or bellows. But be aware that you may need to allow more light to reach the lens when working close-up, so it is a good idea to 'bracket' exposures – in other words, taking extra shots, opening up the lens aperture from the setting recommended by the light meter.

Digital scanning

One area of traditional close-up work that may become obsolete any day now is the copying of photographs and documents. This used to require

Body parts
For images such as these (above and right), no special close-up equipment would be necessary. If the subject is large enough, you can use an ordinary, moderate-to-long, telephoto lens to isolate just part of it to show in essence what a close-up is – a selective view.

a special copy stand to light the picture or document evenly, plus a platform to mount the camera on so that it was looking squarely down on the object to be copied. These days it is far easier, and certainly far quicker, to use a flat-bed digital scanner. With this, it is a matter of seconds to copy an old family photograph and then a few minutes can be spent repairing any scratches or other problems using the appropriate image-manipulation software. Large originals can be scanned in several sweeps and joined together by the software.

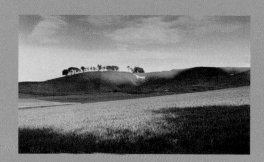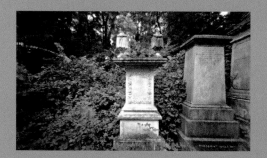

Masterclasses

Cemeteries through a pinhole

For some, the idea of basing a photographic project around a cemetery might sound a little ghoulish. But graveyards, especially if old and slightly overgrown, are often full of wonderful examples of monumental masonry, statuary, and tomb decorations in different styles and from different eras. And the inscriptions on the tombstones, those carefully conceived sentiments, were surely intended to be seen by future generations of visitors.

The mood and atmosphere, the contemplative quiet that are so tangible in cemeteries are perfectly complemented by the type of imagery produced by the most basic of all camera types– the pinhole camera. Although commercial models are readily available from specialist suppliers, all manner of objects – from a shoebox or biscuit tin to a matchbox or soft drinks can – can be converted into perfectly usable pinhole cameras.

With only a minute hole to focus the light, you cannot expect the same critically sharp imagery produced by modern lenses, but the depth of field produced by an effective aperture sometimes as small as f246 is immense, and so focusing is not a problem. And even when the angle of view is extremely wide, you do not see the type of wide-angle lens distortion so familiar to users of extreme optics.

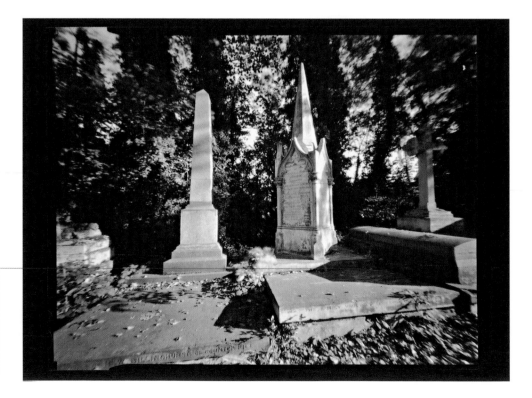

Shadow detail

You need to ensure that the contrast range within the image is not too great – although the light is strong from a high sun, the important shadow areas have not gone so dark that they have lost all detail. By including the black film edge on this image you can see the format's full extent.

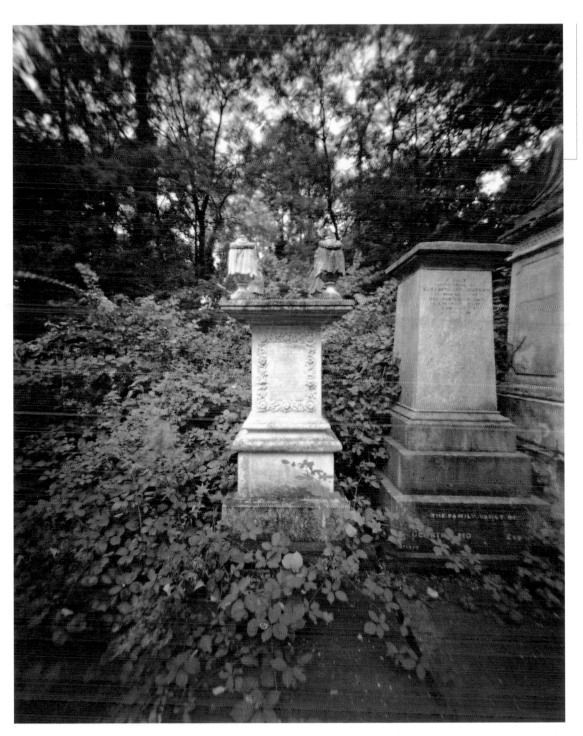

Distortion

This type of distortion occurs when the trees move during the very long exposure times required with this type of camera. Although not normally acceptable in an image, here it helps to produce a slightly 'creepy' atmosphere, as if the scene is being observed by somebody who has 'passed over'.

TIP

Use the following exposure times as a guide with a pinhole camera. These times assume dull, cloudy light: 90 sec (100 ISO); 45 sec (200 ISO); 25 sec (400 ISO); 13 sec (800 ISO); 7 sec (1600 ISO); and 4 sec (3200 ISO).

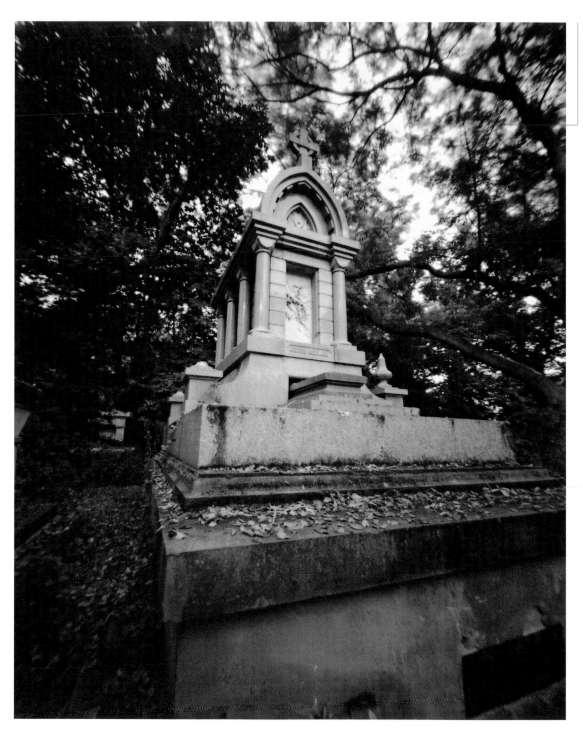

Portrait format
Orientating the camera to give a vertical,
or portrait, format image tends to draw
relationships between objects in the
foreground and those positioned in the
background, thus increasing the sense of
depth and distance in the scene.

TIP

Because of the long exposure
times, camera shake is of more
concern with a pinhole camera.
Even when set up on a tripod, it
is a good idea to add a weight
to the top of the camera if it is
at all windy.

Extreme wide-angle view

The minute hole through which light enters a pinhole camera produces an extremely wide field of view. As you can see from the position of the pinhole camera here (right), even though it has been placed very close to the monument, in the image it produces (far right) there still appears to be a relatively wide area of foreground.

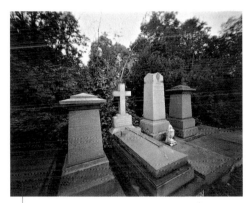

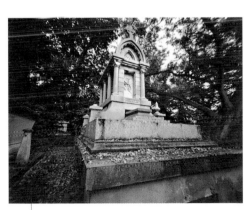

Low-contrast scene

When the sun is obscured by cloud, contrast within the scene lessens, which means that there is less exposure difference between the highlights and shadows. This might be a less dramatic form of illumination, but the softer light allows you to hold detail throughout the image. Exposure times, however, can lengthen into many minutes.

Landscape format

Orientating the camera to produce a horizontal, or landscape, format image produces a feeling of space across the picture, tying together objects on the left and right of the area.

Building a still-life

Still-life compositions can be taken on any format camera but I find the handling characteristics of the medium format most suitable to the pace and approach of the constructed still-life. Before undertaking this type of exercise, it is useful to have a theme in mind – a group of objects to arrange and photograph that you are particularly fond of, perhaps, or that has some sentimental importance to you. All the elements of my still-life here are linked to India, even the old family photograph album.

The objects used in my still-life are all personal family mementoes of India – the old family album at the rear stretches back two generations, while the flute-playing marionette was purchased on a trip to India just a few years ago. However, despite these links I still had to ensure that their styles could all be made to blend to form a coherent composition and that their colouration didn't cause disharmony.

The camera used here was a 6 x 7cm SLR fitted with a moderate telephoto lens. The restricted depth of field of such a lens meant that a small aperture was essential. The camera was tripod-mounted throughout, not just to minimize the possibility of camera shake, but also to have a fixed position to view the developing composition while I went back and forth to add elements or adjust their positions or the angle of the lighting.

TIP

Medium-format SLRs have a mirror lock-up facility. This allows you to flip the reflex mirror up manually and then wait for a few seconds before firing the shutter. This prevents any possible camera shake from the reflex mirror, even when the camera is tripod-mounted.

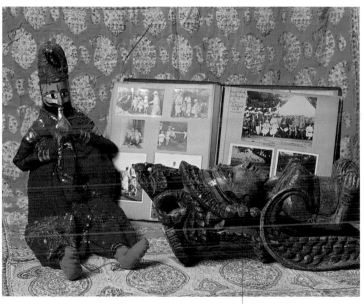

The first stage
An Indian print tablecloth was the starting point for my still-life. The base on which the elements were placed is a tabletop moved back against the wall. At this stage I had my flash to the right of the camera.

Adding elements
The inspiration for this still-life was my family photo album, opened to a page of images taken in India in my grandparents' era. Its placement serves a practical purpose, too, helping to disguise the angle created by the junction of the tabletop and wall. At this stage I am still taking the opportunity to experiment with lighting and here the flash is on the left of the camera. It is usual to change lighting positions whenever an important new element is added, such as this large carved wooden figure.

The final image
This image was taken using studio flash reflected from a white-coloured flash umbrella to the left of the camera. A simple cardboard reflector was positioned opposite to prevent the shadows becoming too dense.

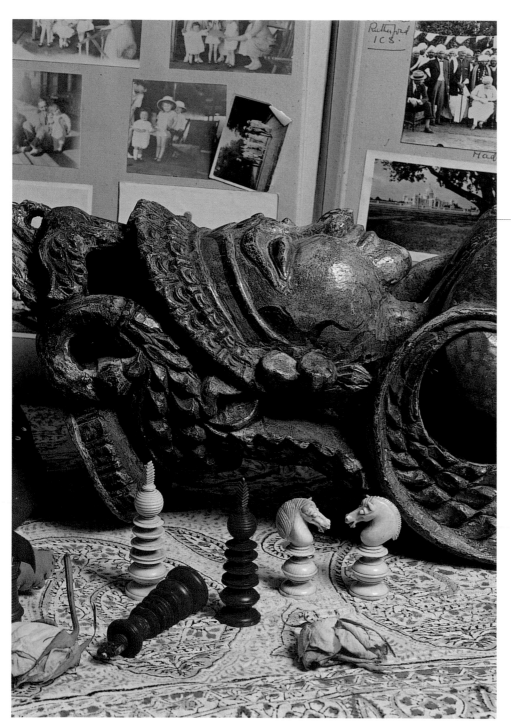

A change of crop

A trap to avoid when building a still-life is that during the construction phase, which can be as quick as a minute or two or stretch over many hours or even days, you can become committed to one particular camera position and image crop. After adding the old chess pieces in the foreground and the faded rose buds I decided to experiment with a portrait format and move in closer to crop out the marionette. Here you can see how depth of field at this magnification has rendered the background photographs just a little soft and out of focus.

Useful references

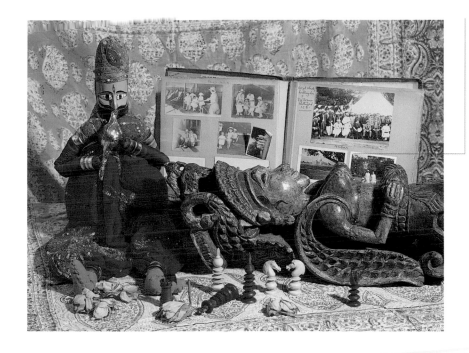

Lighting variation 1

Reverting to the original format and crop I decided to light this image with tungsten photolamps fitted with wide reflector bowls to broaden out the spread of light and soften, to a degree, the inherently contrasty illumination these lamps produce. If you want to diffuse the light itself, then make sure you use heat-resistant material, as the bulbs throw out a lot of heat.

Lighting variation 2

This final variation is my favourite and was taken with diffused studio flash with the addition of a soft focus filter over the lens. The effect of using such a filter is entirely different from defocusing the lens. Here the picture has taken on an age-worn mellowness entirely in keeping with the style of the image elements. Mounted in a period, Victorian picture frame, such a picture would work well in an alcove.

TIP

Most studio flash units have built-in modelling lights – low-power tungsten lamps – that allow you to see how the highlights and shadows will fall when the flash fires. If you are working with accessory flash and don't have this preview facility, simply place an anglepoise-style lamp in the flash position and angle the head to match that of the flash tube.

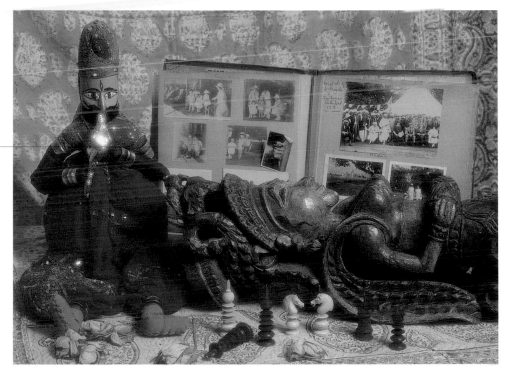

On safari

If accompanied by an experienced guide, then going on safari in one of Africa's game parks is not especially dangerous. But it *is* absolutely thrilling. Sitting in the back of an open-sided four-wheel drive, there really is nothing between you and the wildlife. As you will mainly be driving on unmade roads, a shutter speed of at least ⅟₂₅₀ sec is needed to minimize camera shake, even with a relatively short telephoto.

Cropping for impact

Don't think that you must always show images full-frame. Although the original picture of these elephants (see opposite) is a good composition in its own right, this heavily cropped version looks more like a panoramic shot and is an effective variation on a theme.

The sun in Africa rises quickly to its overhead position, when the air shimmers with the intensity of the heat. All animals like to take shelter at this time of day, making it far more difficult to get a light reading without an accurate spot meter.

Early in the morning and towards dusk is when the animals are most active. If light levels are low, pay particular attention to steadying the camera – even animals habituated to the presence of humans still mostly stay far enough away to make a long lens a necessity. A lightweight tripod or monopod is good, but if you are in the back of a stationary car, use the rollbar as a lens support.

Pad the bar with a small cushion or a soft hat to protect the lens. A polarizer can be good to add punch to the colour of skies, or to strengthen tones in black and white images. In any event, leave a UV filter in place to keep the lens clean.

For subjects in bright daylight a 100–200 ISO film will be fast enough, but for animals in shade, or in early morning and late afternoon light, 400 ISO might be a better choice.

Apart from wanting to record as varied a selection of African wildlife as possible, I also wanted to show something of the animals' habitats and the natural beauty of the country.

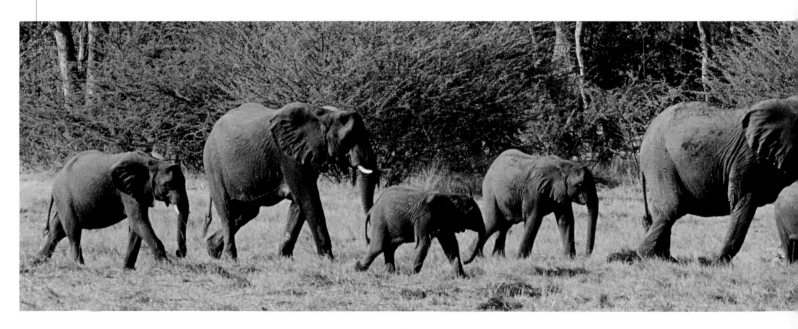

Limiting depth of field

The shallow depth of field of a telephoto lens is a double-edged sword. On the one hand, it ensures that the main subject is the only thing in focus; on the other hand, depth of field can be so shallow that not even all of the main subject is sharply rendered.

A humorous take

It never hurts to keep alert to any potential humour. Hippos live in herds rather than 'nuclear family' groups, and the likelihood is that these are two females with a young calf.

TIP

Keep a container of canned compressed air in your camera bag to clear dust and dirt from lenses, filters, and the inside surfaces of your camera each time you change films, batteries, or memory cards.

Useful references

Apertures and depth of field (*page 16*)
Shutter speeds (*page 20*)
Lens types (*page 28*)
Lens filters (*page 32*)
Film types (*page 34*)
General accessories (*page 38*)
The decisive moment (*page 48*)
Print finishing (*page 74*)

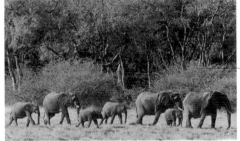

Showing the full-frame view

In this full-frame version of the picture left you can see better the elephants' habitat and gain a more rounded impression of what it is like to experience these magnificent animals in the wild.

Fine printing

No matter how carefully you measure the light from different parts of a scene and expose the image, there is only so much contrast that can be recorded before either shadows block up and become solid or highlights become featureless white. In this landscape, featuring a white horse carved into the hillside at Cherhill Down, in England, I knew that the brightest and darkest areas could not both be satisfactorily recorded, but I had to ensure that the negative retained at least some readable shadow detail to work on.

After film processing and making a contact sheet, you must next make a test strip of the selected negative. This is crucial to determine not only the best exposure for the full-sized enlargement, but also the most appropriate contrast grade for the paper. But if the contrast range of the film original is wide, then some areas of the print may still need burning-in to darken them (the sky area in this example), while others may have to be dodged to lighten them (as in the foreground shadows). If, though, when you exposed the film you made the shadows too dense, then there will be no information to bring out and lightening the tone will simply reveal how empty they are.

The straight print

Here you can see the original, untreated print. I used a grade 3 filter in the enlarger (using variable-grade paper), which produced the correct tonal response in most of the image, though you can see that the sky is too light and the foreground shadows far too dark.

Filter 2

In this version of the landscape, you can see it printed through a grade 2 contrast filter. Overall now, contrast is too soft, but there has been a noticeable increase in the amount of detail visible in the sky.

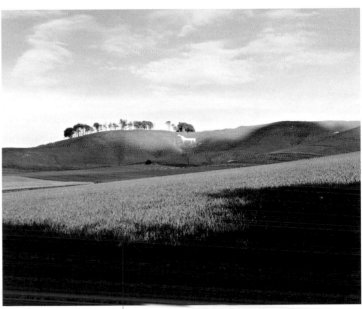

Filter 4

Here, the landscape has been printed through a grade 4 contrast filter and you can see that the middle ground of the scene is far too contrasty.

Filter 5

Printing through a grade 5 contrast filter has produced the blackest blacks.

Useful references

The final image

The final image was produced by printing through a grade 3 contrast filter as it produced the best overall results. However, the remedial treatments to local density described below were required to correct the shadows and highlights.

Burning-in

I darkened the sky by giving it an additional 50% (10 sec) of exposure, while shading the rest of the print with a piece of card. Thus, while the print overall received 20 sec, the sky had 30 sec.

Dodging

While overall print-exposure time was 20 sec, I lightened the foreground shadows slightly by using a piece of shaped card to shade them after only 15 sec.

TIP

A yellow filter was used when the picture was taken to darken the blue sky and emphasize the clouds. This required a 1-stop increase in camera exposure.

136

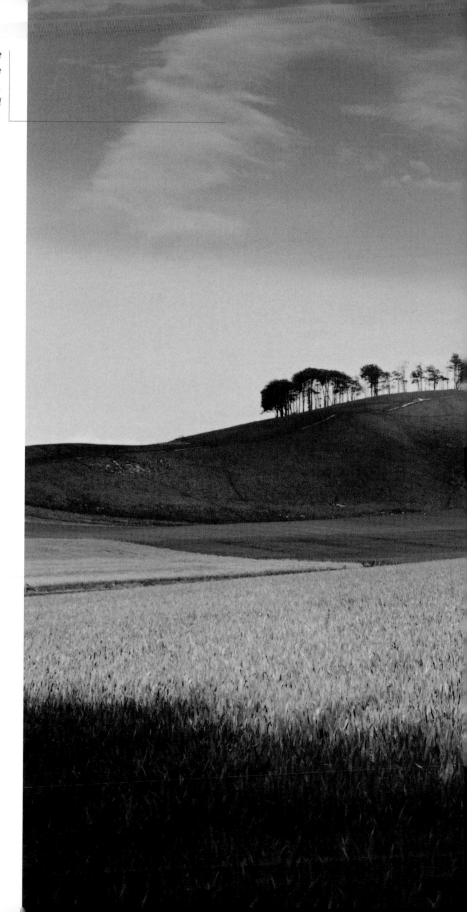

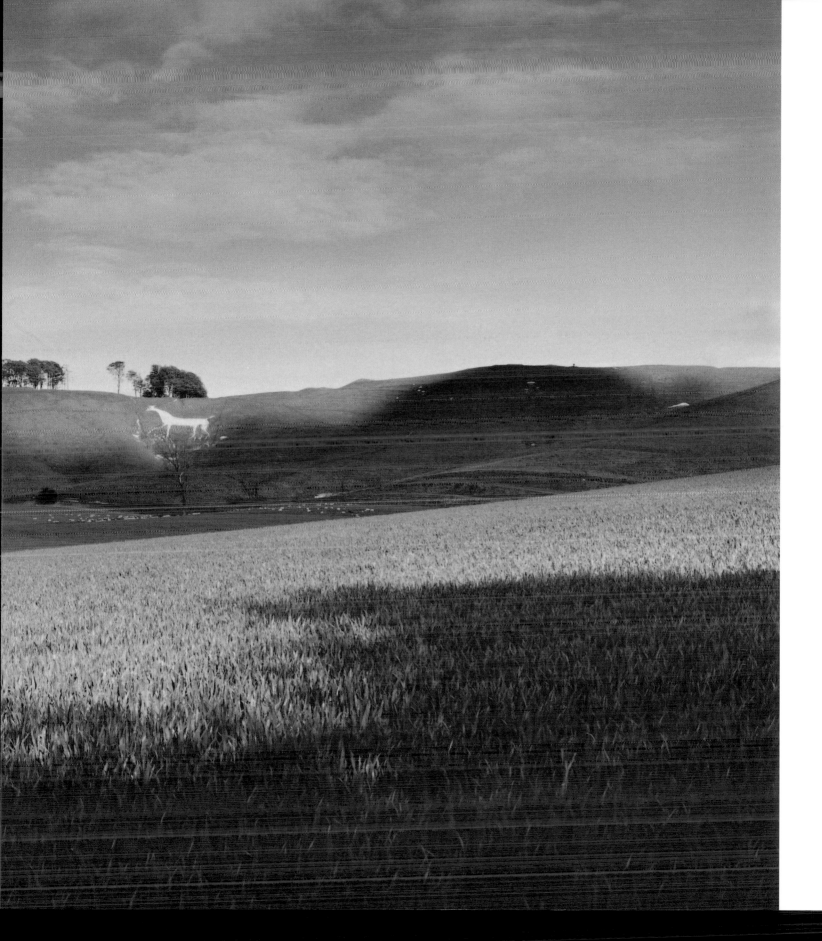

Glossary

Angle of view

The amount of the scene that can be taken in by a lens. This varies according to lens focal length, with wide-angle lenses having a wider angle of view than standard or telephoto lenses.

Aperture

A variable opening formed by a series of overlapping blades set within the lens. The size of the aperture – denoted by f-numbers, often called f-stops – controls the amount, or intensity, of light passing through the lens. A wide aperture, such as f2, allows more light through the lens than a small aperture, such as f11.

Aperture-priority

A type of automatic exposure system in which the user sets the lens aperture and the camera determines the shutter speed for correct exposure.

Autofocus

A lens-focusing system commonly found in cameras. A small internal motor controls the movement of the lens until the image is sharp. Most systems work on the basis that an image has most contrast when it is in sharp focus.

Available light

The amount of light that is normally present in a scene, not supplemented by electronic flash or any other source of photographic illumination, such as photolamps. Also referred to as ambient light.

B

An abbreviation for Bulb. A shutter speed setting that allows you to leave the shutter locked open for as long as the shutter-release button remains depressed. This setting is used for long, manually timed exposures. A useful camera feature for those people interested in night photography.

Backlighting

Lighting coming from behind the subject. This can cause flare problems.

Between-the-lens shutter

A bladed shutter set within the camera lens that opens to expose the film. Also called a leaf shutter. Most often found in medium-format lenses.

Bleach

A chemical solution designed to remove all or part of the developed image of a print, usually as a prelude to further treatments, such as toning.

Bracketing

Taking a number of pictures of the same subject, varying the exposures around the setting recommended by the light meter. Usually done for important pictures when correct exposure is crucial.

Burning-in

A form of local control of print density by which you increase exposure in some parts of a print to make them darker while shading the remainder of the print from the enlarger light.

CCD sensor

An abbreviation for Charge-coupled Device. The light-sensitive sensor in a digital camera that measures and maps the intensity and colour of the light entering the lens from the subject.

CC filter

Colour-compensating filter. Used to change the colour temperature of the light entering the lens to suit the colour balance of the film in use.

Colour cast

A bias towards one particular colour in a colour print or slide.

Colour temperature

A way of expressing the colour content of light as it is recorded on photographic emulsions. It is usually measured in degrees Kelvin (K). Daylight-balanced colour slide film is calibrated for 5600K, for example, and if you expose it in a light source with another colour temperature, such as tungsten light, the pictures will show a colour cast. CC filters are used on the camera lens to correct this problem.

Contact sheet

A set of prints that are the same size as the negatives that produced them, made by printing the negatives in contact with the photographic paper.

Depth of field

The zone of acceptable sharpness both in front of and behind the point actually focused on.

Dodging

A form of local control of print density by which you decrease exposure in some parts of a print to make them lighter, while the remainder of the print receives its normal exposure time.

Extension tube

A tube that fits between the camera lens and body. By moving the lens further away from the focal plane the lens can focus more closely to the subject. Tubes are available in different sizes and can be used in combination to vary the degree of subject enlargement. Make sure the tubes have the right connections to maintain the camera's TTL metering system.

Filter

A glass, plastic, or gelatine disc or square that fits on the front of a lens.

Fixer

A chemical solution of ammonium thiosulphate (a rapid fixer) or sodium thiosulphate (a slow fixer) that is used to make emulsions stable (non-sensitive to light) by removing unexposed or undeveloped halides.

Focal-plane shutter

The most common type of shutter, found on 35mm SLR cameras. A series of blinds moves, usually vertically, just in front of the focal plane to expose the film to light from the lens.

Grain

The clumps of silver-halide particles in a film emulsion that react to light when they are exposed to light and become visible when the film is processed and the image enlarged. A slow-speed film is less sensitive to light and has small clumps of grain; a fast film is more sensitive to light and has large clumps of grain.

Grey card

A card printed with an 18% grey tone. Used to determine exposure for a scene by taking a reading of the light reflecting from it.

High key

A photograph or slide in which light tones or colours predominate.

Highlights

The parts of the subject reflecting the most light. These are represented by the lightest parts of a print or slide.

Hot-shoe

Bracket on top of a camera that accommodates a flash unit. An electrical connection on the base of the hot-shoe triggers the flash to fire when the shutter is fully open.

Inverse square law

This law states that if you double the distance from a point source of light, its intensity diminishes by a factor of four. It is mainly of concern in flash photography.

ISO

Abbreviation for International Standards Organization. ISO film speed relates to the light sensitivity of the emulsion – the higher the number, the more sensitive it is to light. Each doubling of an ISO number from, say, 100 to 200 ISO or from 400 to 800, is the equivalent of 1 stop of exposure.

Light reading

There are two different types of light readings. An 'incident' reading is taken by placing a plastic cone over the light meter's cell and measuring the light falling on the subject. A 'reflected' reading is the more usual type and is achieved by measuring the light reflected back from the subject.

Liquid emulsion

A form of light-sensitive emulsion that can be melted and then brushed on to hand-made or interestingly textured paper, or on to wood, ceramics, fabric, or any other suitable base, and then exposed under the enlarger to a photographic negative. Dry the emulsion with a hair drier before exposing it and treat it as a normal grade of printing paper. Use ordinary processing chemicals to develop and fix the image.

Lith

High-contrast printing system that produces no mid-tones, only black or white, if the lith developer is diluted 1:6. Try diluting the developer 1:9 and remove the print as soon as the image emerges for an interesting result displaying a full range of tones.

Low key

A photograph or slide in which dark tones or colours predominate.

Macro lens

A type of lens designed to produce high-quality images at very close focusing distances.

Medium format

Cameras using 120 or the longer 220 lengths of rollfilm. This type of camera produces negatives or slides measuring 6 x 4.5cm, 6 x 6cm, 6 x 7cm, or 6 x 9cm, and so on. This image size is substantially larger than the more commonly used 35mm, and picture quality is correspondingly higher.

Megapixels

Measure used to describe the resolution of the image-forming sensor in a digital camera. One megapixel is a million pixels. The higher the megapixel count, the greater the potential image quality. For small prints or for images to be published on the web, 1–3 megapixels should be sufficient. For large prints, however, where fine quality is of crucial concern, anywhere between 4 and 6 megapixels might be necessary.

Memory card

Storage device used in digital cameras to record image files. Once files have been downloaded on to a computer hard-disk, they can be deleted and the memory card reused in the camera.

Monopod

Camera support with a single extendible leg, popular for wildlife and sports photography.

Neutral-density filter

A colourless filter that reduces the amount of light passing through the lens without imparting any colour bias. It is available in different strengths and is used most often when the scene is so bright that overexposure cannot be avoided using lens aperture and shutter speed settings alone.

Photogram

An image made by placing objects directly on to printing paper, and exposing them to white light, usually that from an enlarger. Where objects shade the paper completely it remains white after processing, but where the paper is exposed to light it turns black after processing. It is possible to create shades of grey by using objects with varying degrees of translucency.

Photolamp

A type of photographic illumination producing a continuous output (as opposed to flash, which produces a brief burst of intense light), using a large, diffused bulb of between 250 and 500w. This form of illumination gives a colour temperature of about 3200K, which is a redder (blue-deficient) light than daylight or flash.

Pinhole camera

A basic camera comprising a light-tight box that holds a length of film or piece of printing paper and has a minute hole (pinhole) instead of a lens. Pinhole cameras

can be commercially produced, high-quality devices or as simple as a converted shoebox or soft drinks can.

Polarizing filter

A grey-coloured camera lens filter that eliminates specular reflections from surfaces such as glass and water. Polarizers are also used to strengthen colours such as blue skies, making them contrast starkly with white clouds. Also works in black and white to darken tones.

Printing paper (black and white)

Used for producing positive paper images in a layer of light-sensitive silver halides suspended in a gelatine carrier medium. Two types of paper are commonly available: resin-coated paper allows for fast processing times; fibre-based paper produces a richer tonal response and is suitable for archival printing, but it is slower to process and prints are prone to curling.

Rangefinder

A device used in a direct-vision camera for assessing the distance of an object from the camera and displaying this information in the camera's viewfinder to facilitate accurate focusing.

Shutter lag

The delay between pressing the shutter-release button and the shutter actually opening to permit the picture to be recorded.

Shutter-priority

A type of automatic exposure system in which the user sets the shutter speed and the camera determines the aperture for correct exposure.

SLR

An abbreviation for single lens reflex. This design of camera uses a single lens for both picture-taking and image-viewing. Light coming in through the lens is reflected upwards by an angled reflex mirror inside the camera body into a pentaprism and out through a rear eyepiece. To take a picture, the reflex mirror flips up blanking out the eyepiece and allowing the light to travel to the back of the camera where a shutter opens to reveal the film.

Spotting

The use of inks and a fine brush to fill in any white marks on a print.

Stop

A unit of measurement applicable to shutter or film speeds, apertures, and exposures when printing. You double or halve the measure to change by 1 'stop'.

Stop bath

A diluted acetic acid bath used between the developer and fixer stages of film and print processing. It neutralizes developer and so stops it from working.

Tripod

A three-legged support for a camera or lights. A camera tripod is used to hold the camera steady in a fixed position to enable exposures to be made without camera shake. Also used to allow the camera to be smoothly panned to follow a moving subject.

TTL

Abbreviation for through-the-lens. A type of light-metering system housed inside the camera body that measures light coming in through the lens.

White colour balance

A setting on digital cameras that corrects the colour balance of the dominant light source so that colours are accurately recorded. Avoids the need for CC filters.

X

The control on a camera that sets the shutter to the correct speed to synchronize with the firing of an electronic flash. With focal plane shutters, this speed is commonly $\frac{1}{125}$ or $\frac{1}{250}$ sec. On some cameras, the X sign is replaced with a lightning bolt symbol.

Useful websites

www.bobrigby.com
www.calumetphoto.com
www.dewilewipublishing.com
www.pinholeresource.com

Bibliography

Ang, Tom, Digital Photographer's Handbook, Dorling Kindersley, London, 2002
Godwin, Fay, Landmarks, Dewi Lewis Publishing, Stockport, 2001
Hill, Paul, Approaching Photography, Guild of Master Craftsmen, London, 2004
Langford, Michael, Basic Photography, Focal Press, London, 2000
Renner, Eric, Pinhole Photography, Focal Press, London, 2000
Turner, Peter, History of Photography, Exeter Books, New York, 1987
Webb and Reed, Spirits of Salts, Aurum Press, London, 1999

Index

Author's acknowledgements

Thanks to Katie Cowan and John Conway for setting up the project, and to Stuart Cooper and Kate Ward.

To Jonathan Hilton for his rigorous work with the text, and to Peggy Sadler for her design and resourcefulness.

To my wife Charlotte for her love and support, and our children Flora and Matilda, and my sister Annie Cattrell, who have been involved and given me inspiration.

To Michelle Bhatia, Carol Allen-Storey, and Jack Clowes for important help and advice.

Thanks to those colleagues I have taught with in many colleges and on workshops who have influenced me as a tutor.

Picture credits

All photographs by Peter Cattrell, except the following:
p. 7(L) The Art Archive/Victoria and Albert Museum/Sally Chappell; p. 8(T) The Art Archive; p. 9 The Art Archive/National Archives Washington DC; p. 10 © Bill Brandt/Corbis; p. 11 © Martin Parr/Magnum Photos; p. 23 Carol Allen-Storey; p. 30(T, B) Jonathan Hilton; p. 31 Jonathan Hilton; p. 48 Carol Allen-Storey; p. 58(L, R) Jonathan Hilton; p. 92 Paul Kirk; p. 95(B) Paul Kirk; p. 96 Jonathan Hilton; p. 97(B) Paul Kirk; p. 99(L) Paul Kirk; p. 100(B) Jonathan Hilton; p. 105(T) Jonathan Hilton; p. 111(TL) Courtesy of the Hunterian Art Gallery, Glasgow; p. 117(B) Paul Kirk; pp. 132–3(all) Carol Allen-Storey.

All illustrations by David Bootle

Essential Works

Managing Editor Stuart Cooper
Design Manager Kate Ward
Project Editor Jonathan Hilton
Project Designer Peggy Sadler
Indexer Diana LeCore